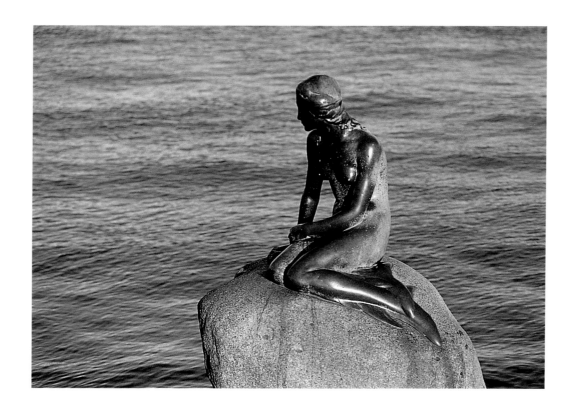

Journey through

DENMARK

Photos by

Tina und Horst Herzig

Text by

Reinhard Ilg

CONTENTS

First page:
The Little Mermaid is still the landmark of the Danish capital.

Previous page:
Small is beautiful: even in Denmark's larger towns, like here in Køge,

many people live and work in centuries-old half-timbered houses

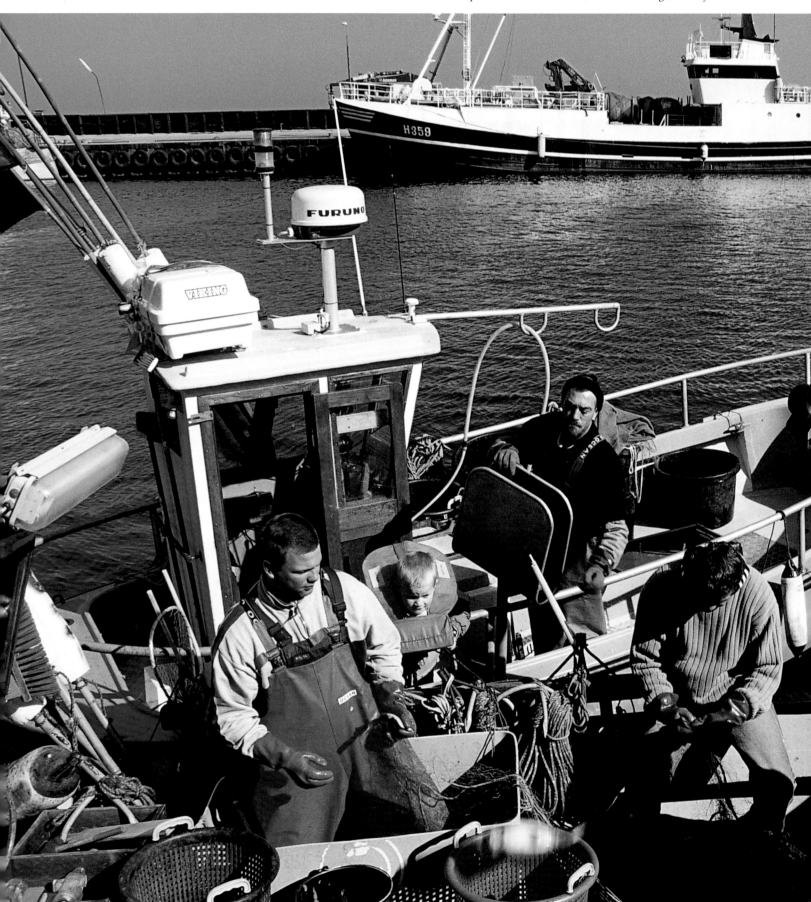

that are cared for with lots of love and just as much money.

Below:
In the nation's countless harbour towns everything revolves around fish

– but the fishers' working conditions are becoming more and more difficult. In the harbour of Gilleleje,

Zealand's largest fishing port, there's more time for chitchat than most would like.

Pages 10/11:
In a country with a 7,450 kilometre (4,630 miles) long coastline it's understandable that bathing culture is a central part of life. During

the summer months a swim in the nearby sea is often a fixed part of the daily routine. Lucky for those who can call a beach hut, like these on Ærøskøbing, their own.

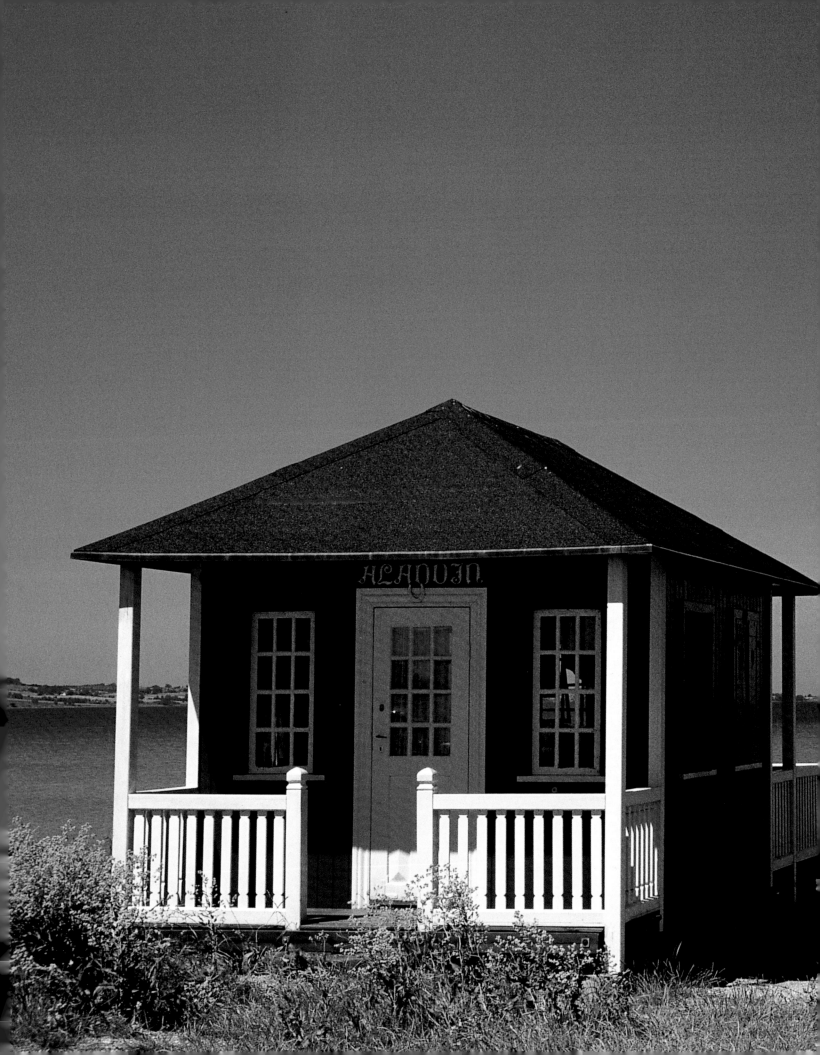

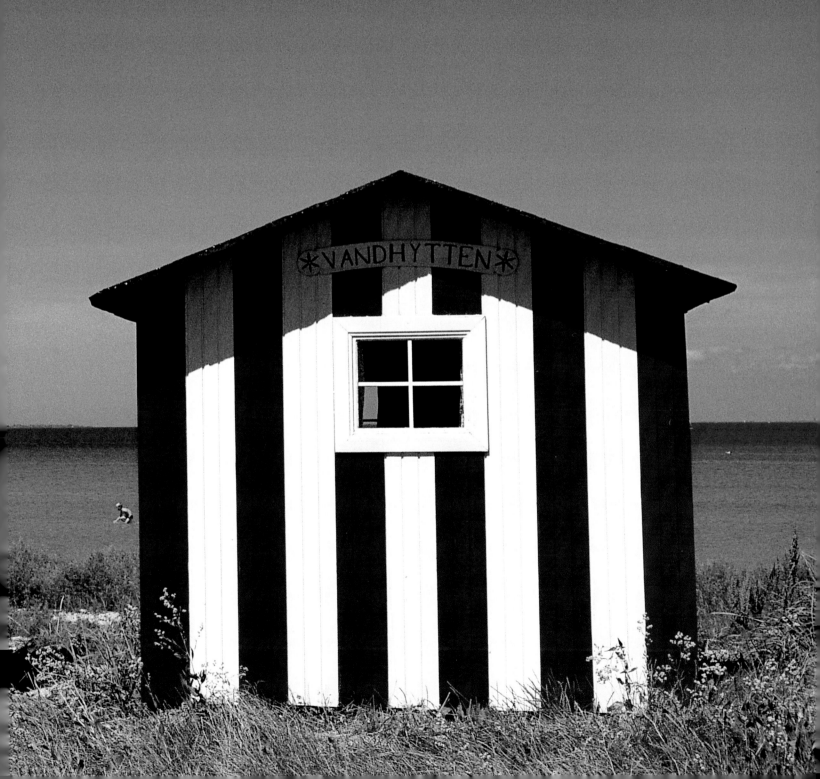

D E N M A R K –

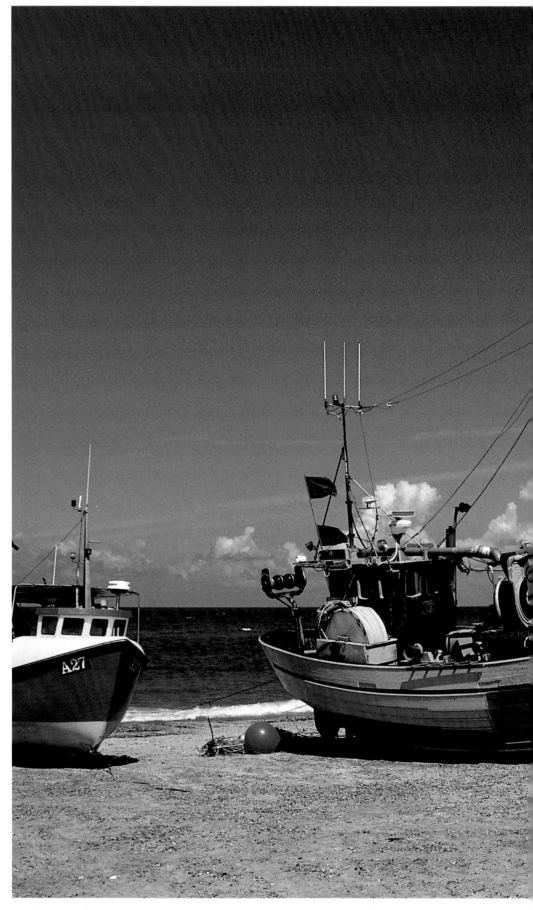

In some places on the rough North Sea coast, fishing boats are still pulled ashore with the help of winches and tractors. But what the observer may see as incomparably picturesque is an extremely hard job for the local beach fisherman.

Denmark: a typical European country? Hardly. Where no house is further than 55 kilometres (34 miles) from the 7,474 km (4,645 mile) long coastline, where the merely 67 kilometre (42 mile) long border to Germany is the only non-coastal boundary to the nearest neighbour, where 5.2 million inhabitants live on roughly 100 of a total of 500 islands, their way of seeing the world will be unique. And they'll go about their business in their own way.

Let's be honest, that's why we love our Danish neighbours. For being so wonderfully laid back, for their informal manner of speaking that quickly negates any hierarchy and for their mischievous trademark »World Famous in Denmark.« We're amazed at the parallel worlds of Denmark: Copenhagen, caught up in the run for money and trends, contrasted by miniature island communities where – a mere 60 minute drive from the metropolis of millions – the inhabitants cosily live to the rhythm of their one ferry. Of course, it's not very nice when our sandcastles are flattened overnight simply because the beach belongs to everyone, and that we're forced to drive at a speed limit of 80 km (50 miles) per hour on dead straight country roads to keep the quota of fatal accidents where it is – far below the European average. Then again the Danes, with their lack of fervour for Europe, have the confidence to publicly debate apparently divine decisions from Brussels in a way that more »model« Europeans would only dream of. And even if we can't always understand the political attitude of this »little band of rebels,« we secretly admire them for their truculence.

THE SMALL, GREAT COUNTRY BY THE SEA

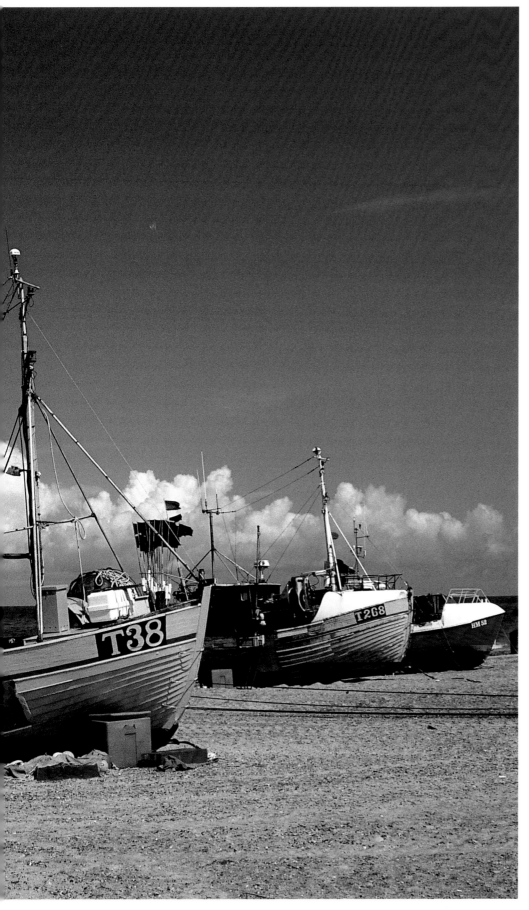

THE CONTENTIOUS LOVE OF CONSENSUS

Denmark is not an island of the blessed, even if the pie there is somewhat more fairly divided than in other countries. Every social issue that comes up between Flensburg and Helsingør is argued viciously. Yet the combatants are all united by a love of consensus, which even politics needs despite differences of opinion. Quite certainly the form of government plays an important role. Its chief pillars in Denmark are the democratic unicameral parliament, the »Folketing«, and the Kingdom, which include the state of Denmark as well as the partially autonomous territories Greenland and the Faroe Islands. The present monarch, Queen Margrethe II, has held the sceptre with a skilful hand since 1972. Even if the constitution allows her to take up only representative tasks, as chairwoman of the state cabinet she signs all laws and after elections charges those candidates to form the government who have the best chances not to be voted down. That's the norm in Denmark: not those who have the majority rule, but those who have no majority against them. Throughout the entire 20th century not one Danish party held an absolute majority: the generally eight to ten parties represented in parliament have often made minority governments possible for years at a time. Prime ministers often call for new elections before the end of the regular legislative period in the hopes of more clear-cut circumstances.

COPENHAGEN AND THE PROVINCE

The principle is a simple one: if it's not Copenhagen, it's the province. Today this centuries-old centralist attitude applies only on paper although greater Copenhagen, with roughly one-fourth of the total Danish population, remains the undisputed economic and cultural hub of the country. People have been moving away from the capital city towards Funen and Jutland since the early 1990s and the road bridge over the Great Belt and the railway tunnel further accelerated this shift. The other urban centres of Denmark have profited the most from this: Århus, Odense, Aalborg and Denmark's largest harbour city Esbjerg, as well as many of

the smaller towns of Jutland. Where it once took roughly four and a half hours to get from Copenhagen to the eastern coast of Jutland, today the economic centre of power in the Kolding-Fredericia-Middelfart triangle can be reached within two hours – fast enough to offer companies an alternative to the exorbitant prices of Copenhagen.

Besides »Det Kongelige«, Copenhagen's royal theatre, there is a surprisingly dense array of sophisticated cultural events all over the country. For instance, the Wagner Music Festival in Århus has long attained international renown while art lovers from all over Europe have discovered the numerous museums of modern art situated in Kolding, Silkeborg, Herning and Aalborg. In each of them the Jute Asger Jorn, Denmark's leading mind in the international Cobra group (short for Copenhagen-Brussels-Amsterdam) that formed the artistic avant-garde in the post-war years, has a special place. Like other Danish Cobra members, his experimental painting was inspired by the ornaments of the Viking age, relief sculptures of the Romanesque and Medieval limewash painting. Among the most outstanding artworks are the mosaics and paintings of the cathedral of Ribe, the oldest city in Denmark. Created between 1982 and 1987 by Carl-Henning Pedersen, they were initially all the more disputed since Pedersen is a professed atheist – today, famous beyond national borders, the artworks are considered by Danish pragmatists an expression of »a seeker's enthusiasm for divine nature.«

One interesting example of successful independent cultural policy in the province is the town of Holstebro in western Jutland. With its 35,000 souls, 40 years ago it was practically an outpost of urban civilisation. Rather than placing their bets on investment subsidies and cheap construction plots, in the early 1960s the town elders placed them entirely on cultural policy as a driving force for resettlement – successfully. Today Holstebro surprises its guests with treats like a small, but very fine art museum, a Giacometti and other sculptures in its pedestrian zone, the Odin Theatre, one of Europe's most highly regarded independent theatres, and the renowned Peter Schaufuss Ballet. Furthermore Holstebro calls the world's first permanent laser sculpture its own.

The pathway to intellectual independence from Copenhagen was already taken in the late 19th century by the Skagen painters. The best known Danish artists' group to this day, centred around Holger Drachmann, Peter Severin Krøyer and Michael Ancher, brought the Jutland province to unforeseeable popularity. Their names today stand like no others as synonyms for the northern lights in painting, and the art-historical past still puts its mark on life in the former fishing village of Skagen. The painters' perspectives of the landscape, beaches, sea and the simple people draw visitors all year round to the country's most northern community.

EDUCATION FOR THE FOLK

One of the outstanding characteristics of Danish society is its pronounced horizontal, non-elitist way of thinking. Folk high schools, folk universities, folk theatre, even the »Folk's Assembly,« the »Folketing«, speak a clear language. Here »folk« has no musical or tourist-trap connotations; in Denmark these institutions are wholeheartedly »folkelig«, simply put »close« or »connected« to the people. The pioneering champion of a community close to the people and the key figure for the Danish system of »folkehøjskoler« was Nikolai Frederik Severin Grundtvig (1783–1872). The poet and preacher left behind far deeper marks in Danish society than his prominent contemporaries Søren Kierkegaard and Hans Christian Andersen. At the beginning of the 19th century, the so-called Golden Age, the Danish people were split into two worlds and the educated minority of the middle class and civil servants looked down contemptuously at the rural population. Like a philosopher of the Enlightenment, inspired by the ideas of Rousseau and Pestalozzi, Grundtvig pursued the aim of countering the middle class Humanist schools with »folkelig« »Schools for Life« in order to free the lower

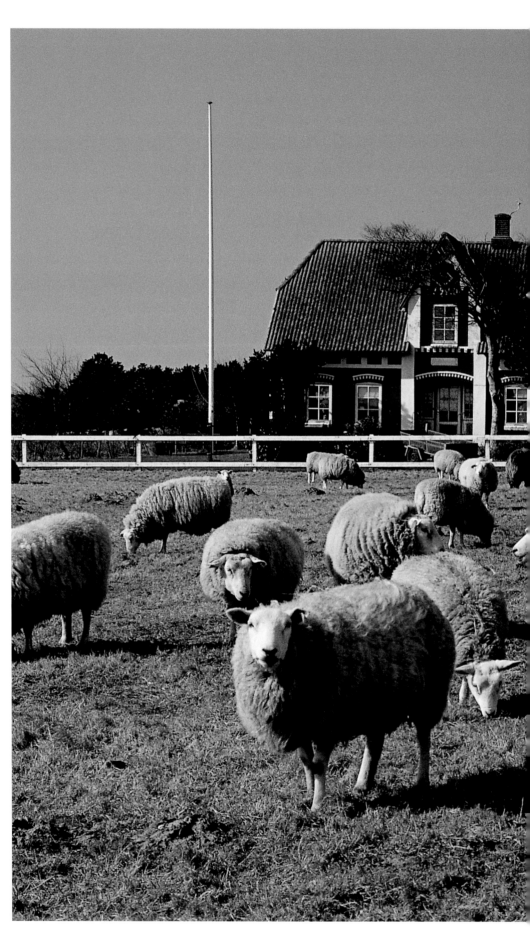

On Rømø, reed-thatched houses and herds of sheep are part of the typical North Sea island picture. The slant of the trees leaves no doubt about which way the wind blows here.

classes from their forced social passivity. The idea was that the schools should centre not around the hardly-mastered written language, but around »the living word,« reasoning that only the gripping spoken language is creative and vitalising. Denmark's great past was accessible only in sagas, myths and poetry, but dealing with their own history should make the people capable of dealing with the problems of the present and the future. Grundtvig was by no means a revolutionary, since his goal was »life enlightenment« (oplysning) rather than education (opdragelse). The founding of the first »folkehøjskole« in 1844 in the town of Rødding in southern Jutland initiated the triumphal entry of non-diploma educational institutions, of which there are still roughly 90 distributed across the country today. Weekly, monthly or half-year courses teach astrology to zoology, never focusing on specialist knowledge, but rather on learning for life in the community. Grundtvig is present everywhere in Denmark: more than 2 million copies of the »folkehøjskoler hymnbook« are distributed among most Danish households, which also includes very secular songs: »Daily acts are worthy of heroes.«

THE HIGHS AND LOWS OF NEIGHBOURLY RELATIONS

When Denmark entered the Schengen Treaty in the year 2001 as one of the last EU members and did away with its border controls, the conservative Danish People's Party purchased the now abandoned Danish-German border post in Rudbøl, raised the »Dannebrog«, the Danish flag, and loudly announced its displeasure over the alleged sell-out of Danish interests. And they knew that they spoke for many of their political opponents as well. The Danes: a club of nationalists?

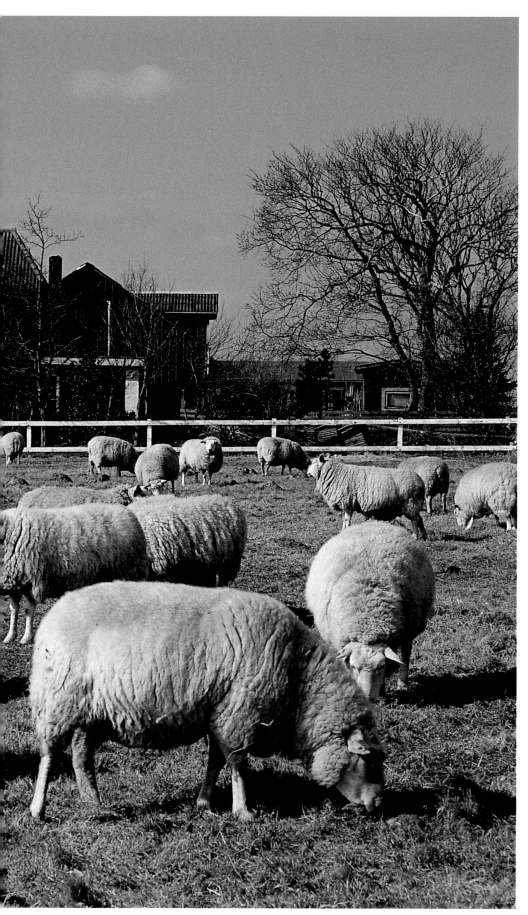

Yes and no. Yes, when they are protecting the more egalitarian Danish model of society from the more centralist Brussels »corporate administration.« For example if EU-wide tax harmonisation is pushed through, Denmark will have to give up its 100 percent luxury tax on automobiles, which finances most of the social system. Yes, when it's a matter of opening the country's real estate market to foreign buyers – which would prevent many Danes from purchasing their own soil in the future. Yes, when they are declaring their belief in Danish society and the privilege of being able to live in a prosperous, yet social, community with a flurry of flag and banner waving.

No, when it's a matter of Danish global commitment. When the Baltic nations were struggling for independence from the Soviet Union, Denmark was a reliable partner to them both economically and politically. The little kingdom gets involved in the world's hotspots not only with their military presence, but to the same extent with developmental aid. No, when it's a matter of state-of-the-art technology and medical research, in which Denmark takes a leading world role.

Its varied history and its physical closeness to Germany make it natural for the Danes to follow the political events in Germany with great interest, although its relationship with the big neighbour to the south has taken a surprising turn. After decades of bitter wrestling for dominance in Schleswig, which sadly peaked in the German-Danish War of 1864, and still decades after the painful years of German occupation in the Second World War, many German influences were met in Denmark with candid scepticism. The fall of the Berlin wall led, as in many other European countries, to the question of whether the reunited larger neighbour would remain a reliable partner. Response has been positive, though. Many Danish farmers were involved in the privatisation of former collective farms in eastern Germany, and the new capital of Berlin has become a popular travel destination for many culturally and historically interested Danes. No other major metropolis of Europe is as close to Denmark, and the dense network of ferries in the Baltic Sea make even day trips between Copenhagen and Berlin or Hamburg possible.

17

The two minority populations on either side of what today is more like a virtual border are a curiosity: a Danish population of roughly 30,000 lives between the Eider and Flensburg in Germany, while somewhat fewer Germans live between Flensburg and the Kongeå, the King's River in Jutland. For decades the minority policies of both countries have been considered exemplary for Europe, nevertheless both sides – in spite of inevitable European integration processes – make efforts to demonstratively defend their cultural uniqueness. German schools in Sønderjylland and Danish schools between Westerland and Rendsburg often force parents to decide between two lifestyles. The newspapers of the respective minorities, the »Flensborg Avis« and »Der Nordschleswiger«, watchfully eye political and cultural happenings in the region.

NORDIC TIMES

The quarrels between the Nordic sister nations of Denmark, Sweden and Norway, which have been linked to one another for centuries by tight historic bonds, are countless and legendary. For instance, Norway was a part of the Danish kingdom from 1397 until 1814 and the modern Swedish provinces of Skåne, Halland and Blekinge formed the east of Denmark until 1654 – placing the capital city of Copenhagen in the centre rather than on the periphery of the country as it is today. In particular, the first half of the 17th century under the aegis of Christian IV was a time of prosperity as seen in the impressive legacies it left behind, in spite of expensive warring conflicts with Sweden. Buildings in the Dutch Renaissance style, like the Stock Exchange and Rosenborg Castle in Copenhagen or Frederiksborg Castle in Hillerød, hint at the wealth that the Øresund tolls swept into the monarch's treasuries: every ship headed to or from the Baltic Sea had to anchor in the harbour of Helsingør and pay duty on its wares. Whoever tried to avoid it had to fear instead the impressive canons of Kronborg Fortress.

As great as Denmark's economic dominance was, its cultural influence on Nordic territories equalled it: those who wished to be pastors or teachers in Norway or Iceland had no choice but to study in Copen-

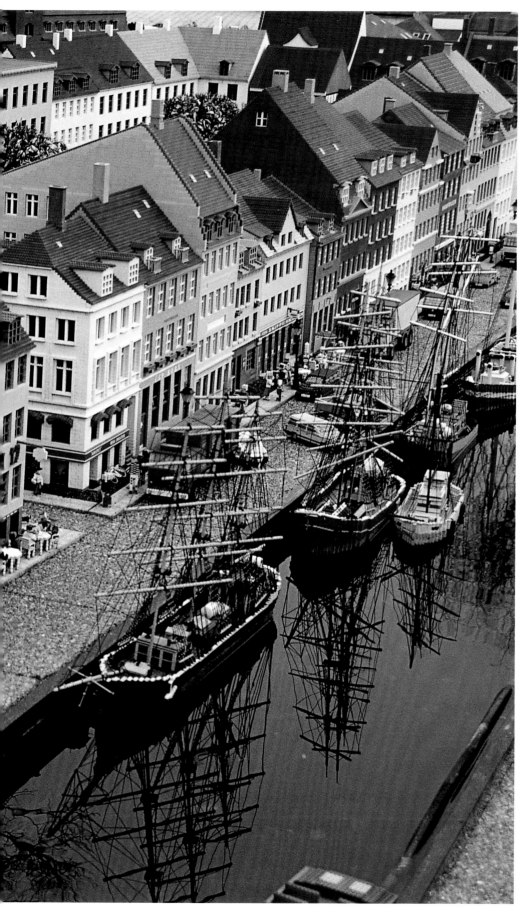

Not only children walk through Legoland in awe of the remarkably perfect world of little, colourful bricks. The miniature world has long been transformed into a theme park worth spending the whole day in.

hagen. The cultural centre of northern Europe was the connecting link to the middle of the continent. The defeat of Denmark in the Napoleonic Wars at the beginning of the 19th century changed large parts of the political landscape so they took on the form they still have today: the Treaty of Kiel forced Denmark to cede Norway to Sweden, but, with a negotiation trick, it was able to secure for itself the former Norwegian territories in the North Atlantic, the Faroe Islands, Iceland and Greenland. Iceland became independent after its English occupation in the Second World War, but the Faroe Islands and Greenland are still partially autonomous elements of the Kingdom of Denmark. Denmark's benevolence towards its North Atlantic territories after the end of the war has, however, given way to a tense discourse on the billions it pays in subsidies and Copenhagen's political influence. In the case of Greenland, the difficulties in bridging the disparities of the ethnic cultures and their ways of life long ago proved to be a permanent problem. For many years alcoholic Greenlanders, often seeking economic salvation in Denmark, were fixtures in the streets of larger Danish cities. Danes who have one of the tax-incentive jobs in Greenland often live for years in a parallel world alongside the indigenous population.

The close northern neighbours are today a more fraternal band, especially united towards Brussels, although the Danes, Swedes and Norwegians have very differing European policies. As in any proper family there are, of course, any number of animosities and sensitivities – but the Danes usually come out on top. Their unaffected, fundamentally liberal attitude towards life, their marked sense of community expressed not least in enjoyment of every type of celebration, make the

The fishers' cottages in the harbour of Skagen light up red as oxen's blood. The fruits of the sea can't be had fresher than here. The morning tranquillity will soon be replaced by the lively clamour of gourmet-lovers.

Danes the southern Europeans of the North. And on a journey through Denmark one often meets Norwegians and Swedes, whose far more regimented community units can be astoundingly far from the Danish model. Here no one asks about beer licenses or age when buying beer; here the cafés, bars and restaurants are often open until late at night and whoever doesn't come today will come tomorrow.

THE DANISH WORLD OF BEAUTIFUL THINGS

They adorn tables and cupboards from Zurich to New York; their elegant functionality is now a legend: items of practical use with the seal »Danish Design«. Whether coffee pots, corkscrews or cooking pots – whoever loves the beauty of simple, clear forms and has money to spend cannot avoid products designed in Denmark. They are certainly not mere fashion, but the result of a centuries-long culture of design. As early as 1775 the Royal Copenhagen Porcelain Factory was established whose products are adorned with three waved lines symbolising the three through-waterways to the Baltic Sea: Lillebælt, Storebælt and Øresund. It was followed in the mid-19th century by Bing & Grøndahls Porcelain Factory, which also enjoys international renown. The works from the forge of silversmith Georg Jensen and the Holmegaard glassworks are on a similarly high level of quality and style. The companies often contract famous artists, contributing the great success of Danish Design.

With the exception of pinewood indulgencies, Danish furniture also has international renown. Its father was the head of the Art Academy's Furniture School, Kaare Klint (1888–1954). His students refined

his fundamental designs to produce eminent products and many design trends in the furniture industry began their course in the exhibitions of the Copenhagen cabinetmakers' guild in the years from 1927 until 1966.

Today Arne Jacobsen (1902–1971), whose chairs can be found around the world, is still Denmark's best known furniture designer. The lifestyle design of Bang & Olufsen holds a special place in the world of beautiful things: the luxury stereo systems from the Jutland province around Struer are standard royal giveaways at state visits in Copenhagen. There's hardly a household of the upper ten thousand between Moscow and New York that lacks the advanced design from the former radio factory; hardly a museum of modern design that doesn't show pieces from the small Danish town in the Limfjord.

But the Danish world of design's greatest merit is the fact that it never leaves solid ground in spite of the most unconventional creations and hence also draws a broad spectrum of buyers beyond luxury boutiques. Typically Danish.

Pages 22/23:
The chalk cliffs of Møn in the very east of Denmark are some of the most outstanding natural monuments of the country. On a clear day the tips of southern Sweden and the German island of Rügen are visible from its up to 148 metre (486 feet) high peaks.

Pages 24/25:
In Denmark it's very clear that the Baltic Sea is an inland sea: many of its bays and shoreline landscapes remind one more of lakes and are a quiet contrast to the rough expanses of the North Sea, only a few miles away.

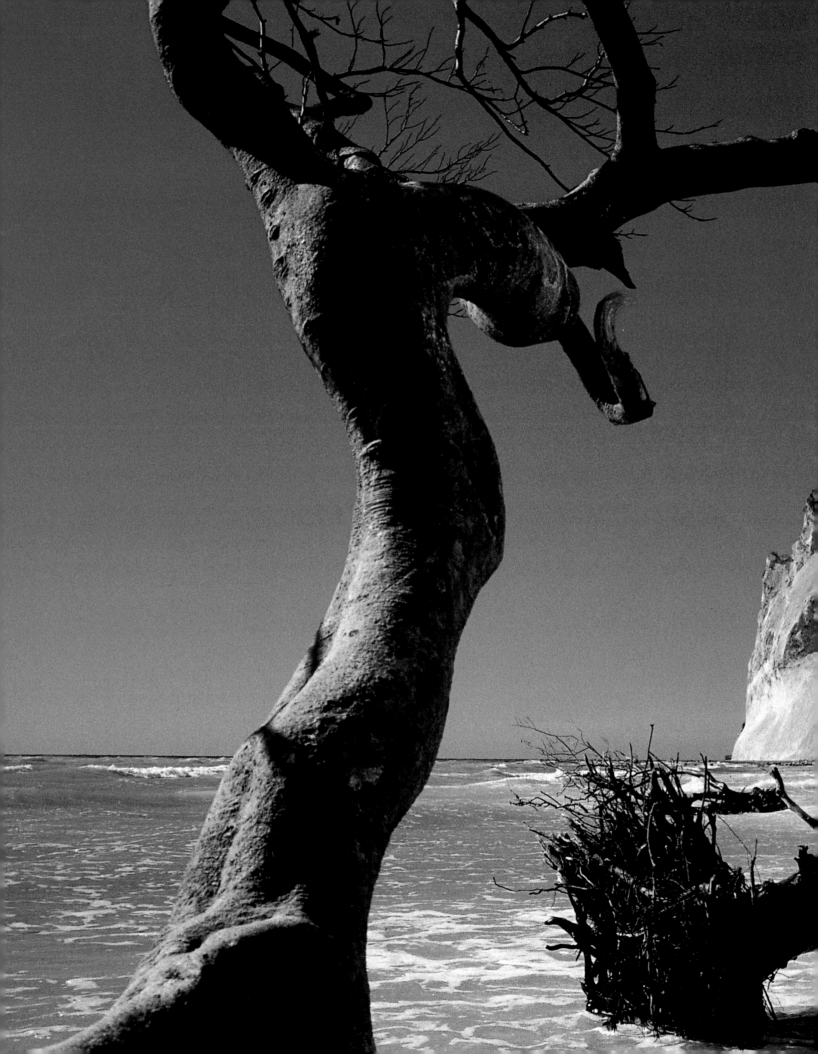

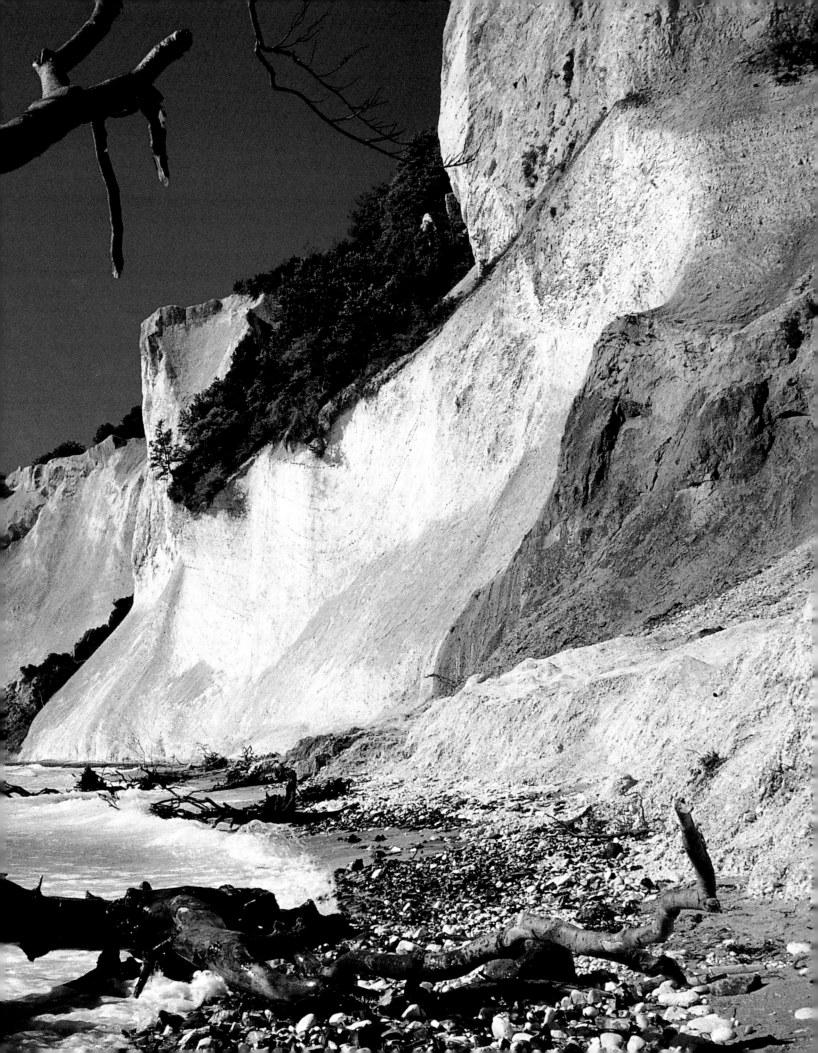

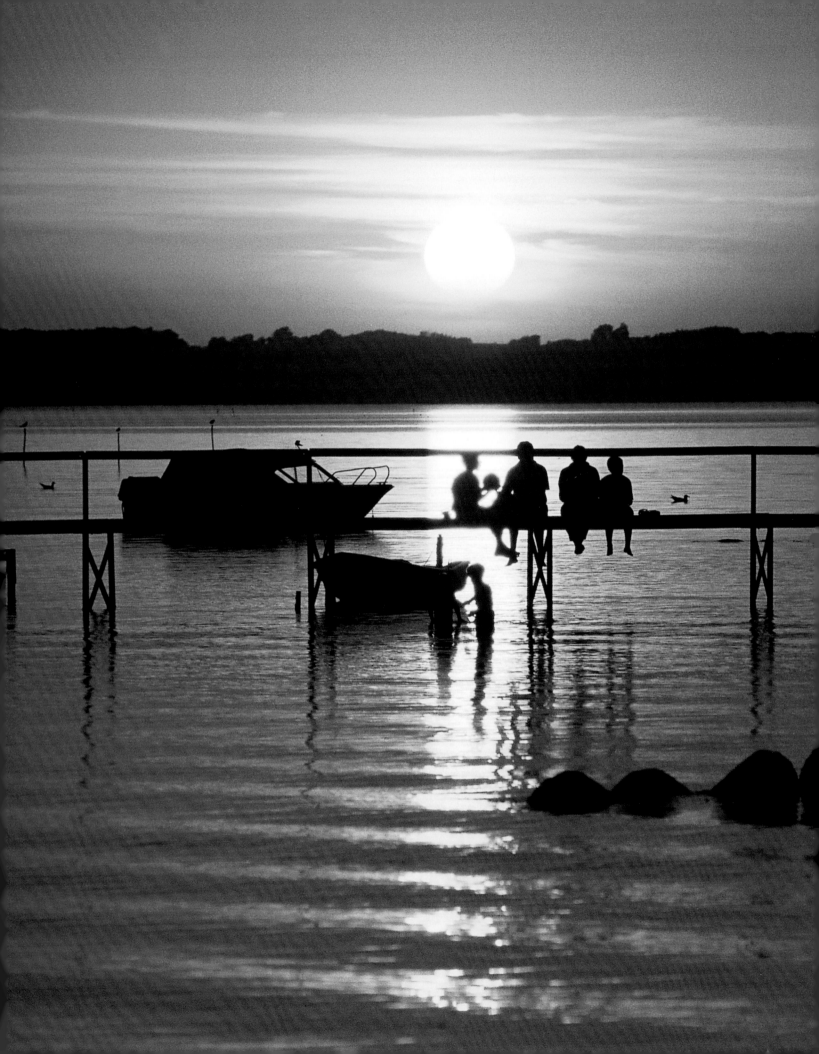

THE EASTERN DANISH ISLES

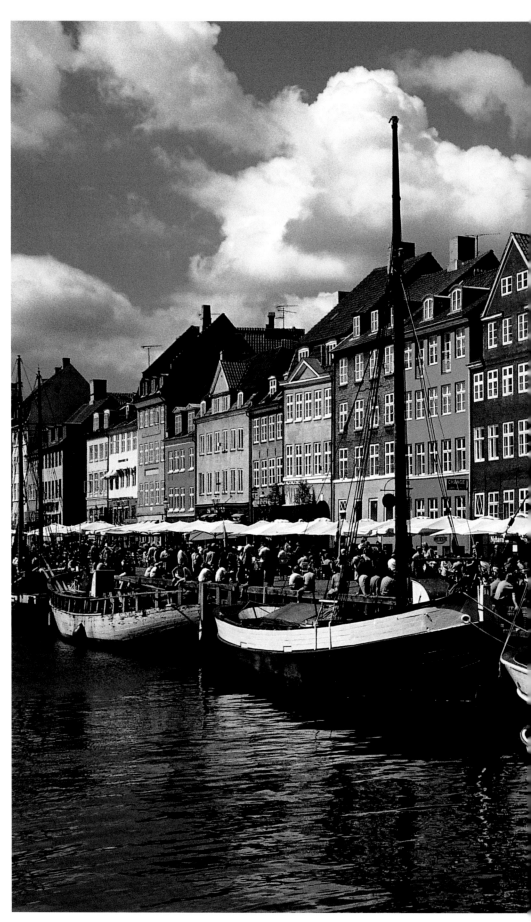

When we think of Denmark we often think only of the Jutland mainland – but the islands of Lolland, Falster, Møn and Sjælland (Zealand), with the capital city of Copenhagen, are just as fascinating: well-kept manor estates, castles and parks testify to centuries of prosperity and to both the attractive and charismatic powers of the Danish metropolis, which was situated in the centre of the nation before the loss of Skåne, Halland and Blekinge to Sweden. Today it still does in another way: since the completion of the bridge over the Great Belt in the west and the Øresund crossing between Copenhagen and Malmö, the eastern Danish islands are suddenly landlocked with the rest of Europe.

The islands are most spectacular in the very east: on a clear day the up to 148 metre (486 feet) high chalk cliffs of Møn allow a view of Sweden and Rügen. Otherwise eastern Denmark's charming beauty lies in the still, harmonious interplay of fjords, islets and bays with the gently rolling land and tree-lined avenues that disappear at the horizon. So it's no wonder that many Copenhageners spend the fresh summer days on their own doorstep as is, and always was, trendy: traditional bathing resorts like Marielyst on Falster or Hornbæk and Gilleleje in the north of Sjælland, scenic Odsherred and enchanted Møn.

Those who wish to follow the footsteps of Danish history will inevitably land at Roskildefjord: Denmark's rich and varied Viking history, documented by ship finds that can be marvelled at in Roskilde, is just as impressive as the cathedral there in which all of the country's monarchs have been laid to rest since Margrete I (died 1412).

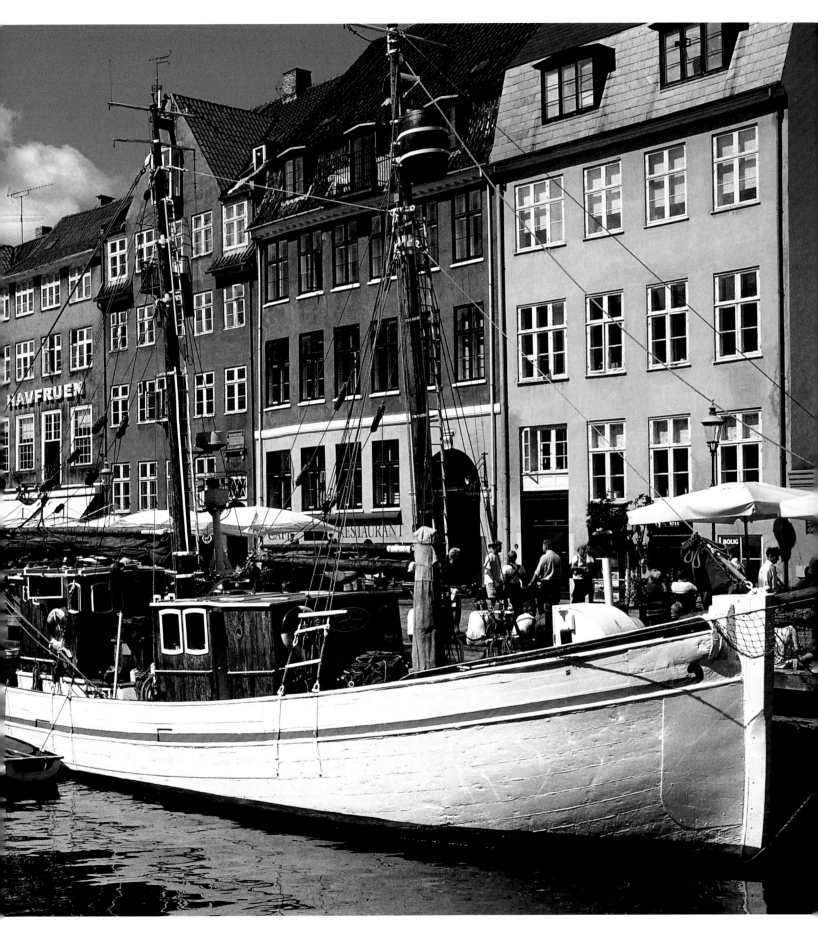

Below:

*Only a few steps away
from the harbour and
Kongens Nytorv, the four
identical palaces of
Amalienborg Slot serve
as the home of the*

*Danish royal family in
the capital city. In the
centre of the octagonal
palace square, King
Frederik V has been
keeping watch since 1768.*

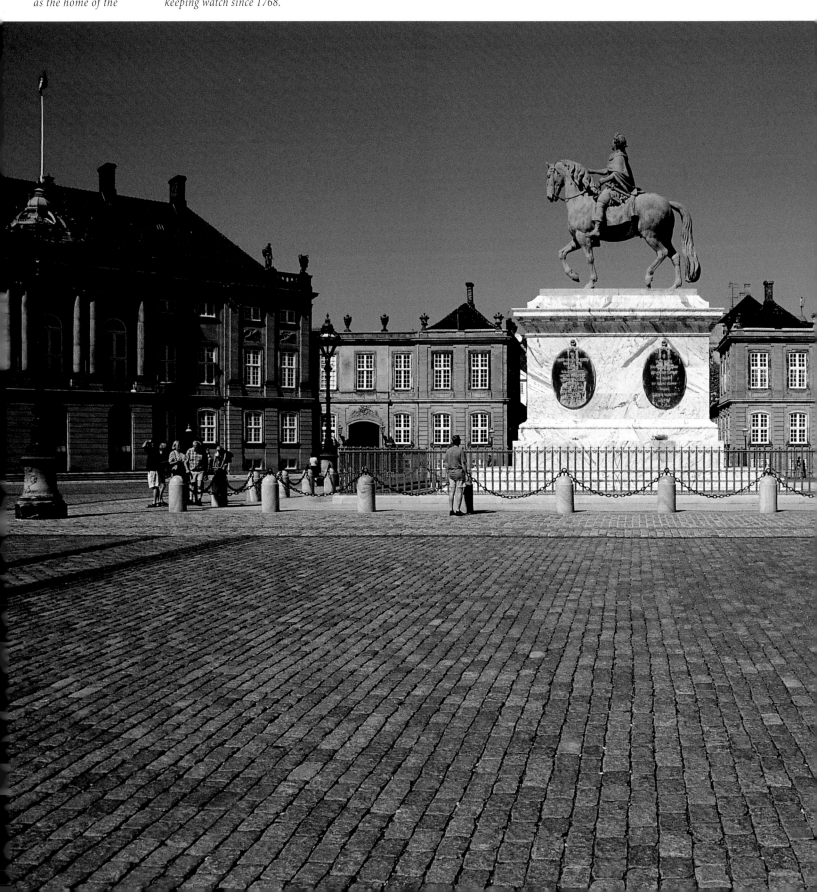

Above right:

Just as impressive as the royal palace is the nearby marble church, Frederikskirke, whose cornerstone was laid in 1749.

Centre and below right:

Official life inside Amalienborg Palace is like a relic from Hans Christian Andersen's times. The picturesque climax is the daily changing of the guard at 12 o'clock noon on the palace square, which can be a bigger or smaller event, depending on whether the Queen is home.

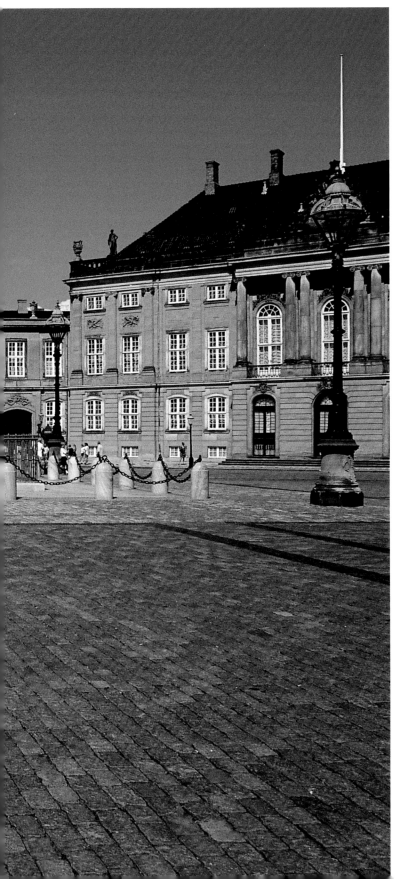

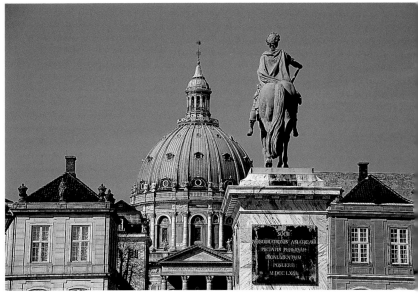

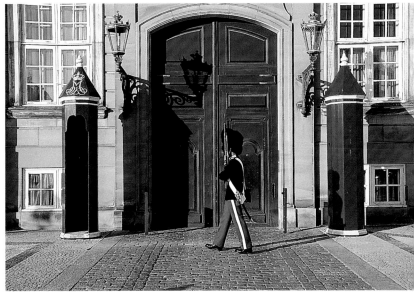

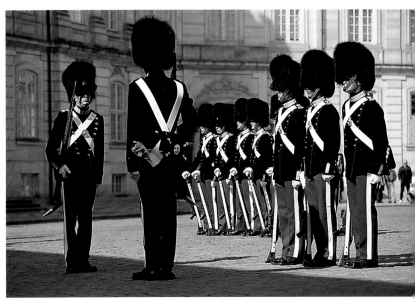

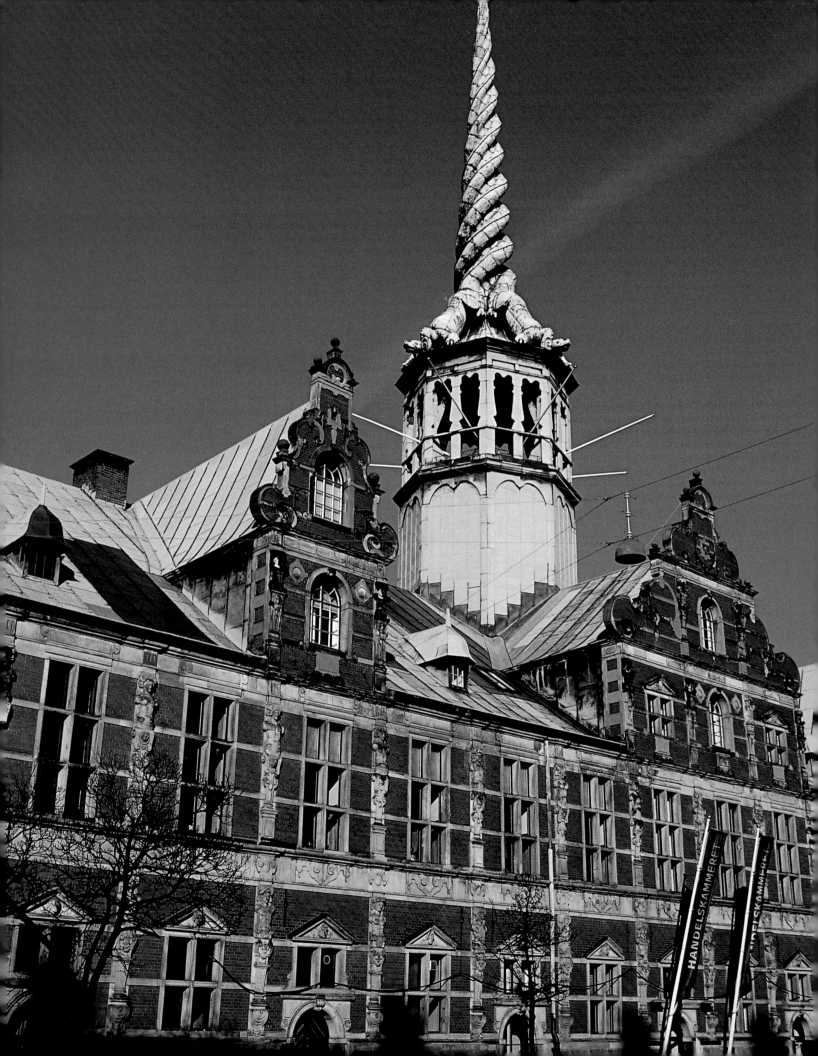

The Copenhagen Stock
Exchange built in 1640
is probably the most
impressive inheritance
left by Christian IV. It
is considered one of the
loveliest Renaissance
structures of northern
Europe. Its most charac-
teristic detail is the
twisted tower roof that
four dragons form with
their tails.

»The Black Diamond«
on the shore of
Christians Brygge is the
home of the Royal
Library and Imperial
Archives. The bizarre
building is one of the
stars of Copenhagen's
latest architectural
achievements.

The National Gallery in
Copenhagen presents
enormous collections of
Scandinavian and inter-
national painting as well
as sculpture from the
15th century to modern.
The new connecting
wing is an architectural
tour de force containing
contemporary Danish
art.

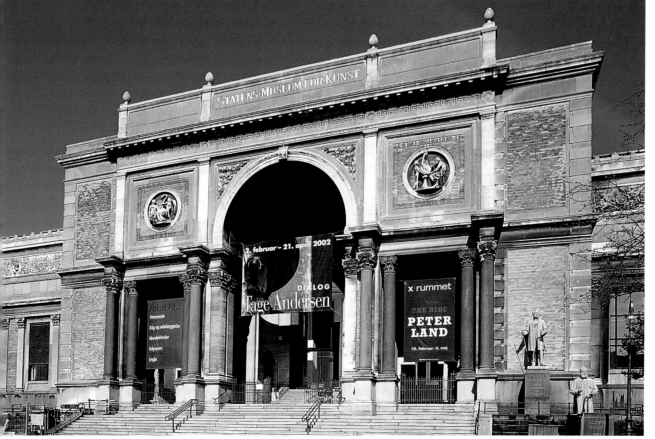

Above:
In earlier times fish were sold on the market of Gammel Strand in Copenhagen, today the street across from the castle church and Christiansborg Slot is one of the most famed addresses for gourmets of seafood cuisine.

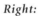

Right:
As soon as the temperatures allow many Copenhagen restaurants move outdoors. The streets around Nyhavn in particular are a favourite meeting place for everyone who wants to see and be seen. But it's still evident that the heart of Copenhagen's harbour life once beat here.

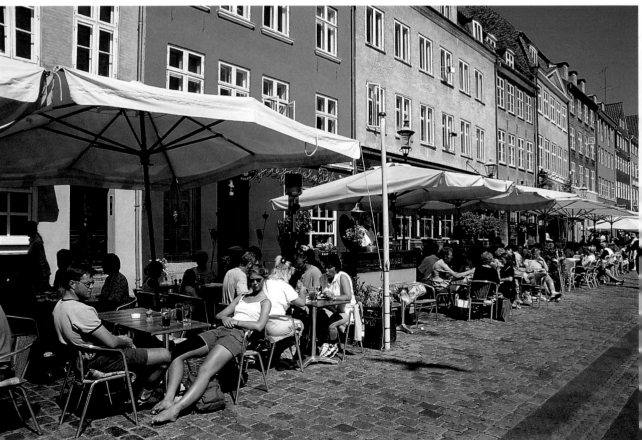

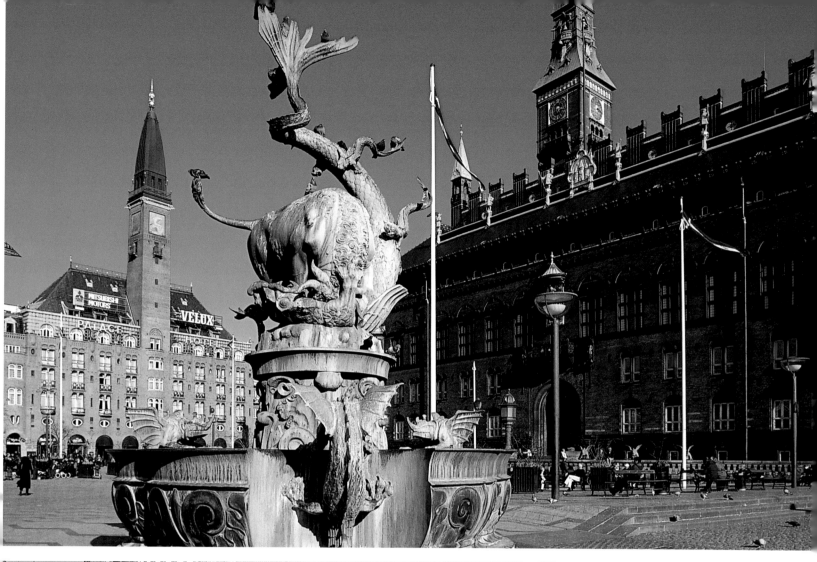

Above:
*The Town Hall Square
is the hub of all public
events and the most
important traffic node
in Copenhagen. Like the
Town Hall itself it was
designed in the Italian
Renaissance style of
Siena, but the magistrate
building was completed
in 1905.*

Left:
*Cappuccino, espresso,
latté – Copenhagen's
cafés have become inter-
national in recent years
and successfully offer
good service. The Nordic
longing for southern
flair is obvious.*

33

For many years the Louisiana Museum in Humlebæk held a monopoly in modern art – until Copenhagen, as Europe's 1996 Cultural Capital, acquired the Arken Museum of Modern Art. The architecturally quite unusual building is situated in the middle of the dunes of Ishøj Havn and exclusively presents current trends of international contemporary art. Architect Søren Robert Lund was a mere 25 years old when he won the architectural competition.

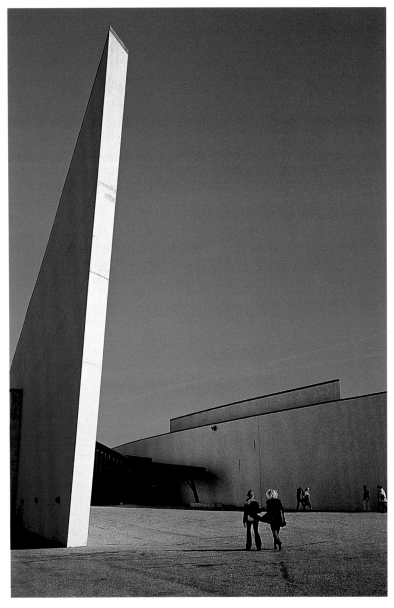

The porcelain factory of Royal Copenhagen dates from 1775. Three waved lines, symbolising the three through waterways to the Baltic Sea, adorn the internationally treasured china. Today Royal Copenhagen also runs the silversmith of Georg Jensen and the Holmegaard glassblowing works located on the eastern end of the Strøget.

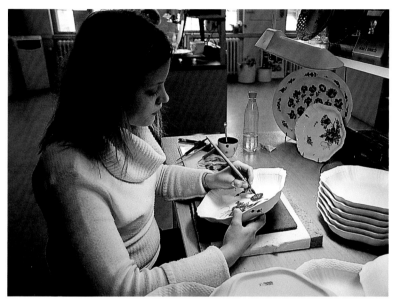

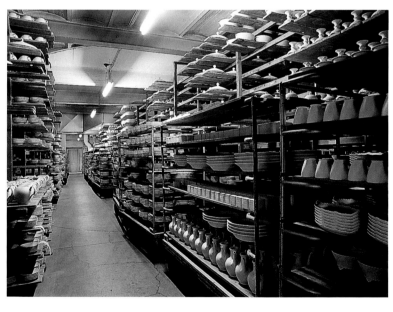
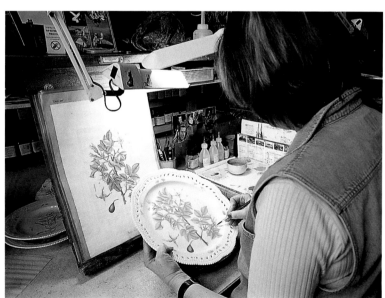

Rosenborg Slot was constructed between 1606 and 1634. Originally designed as a summer residence outside of Copenhagen, the Renaissance building now houses the Danish crown jewels.

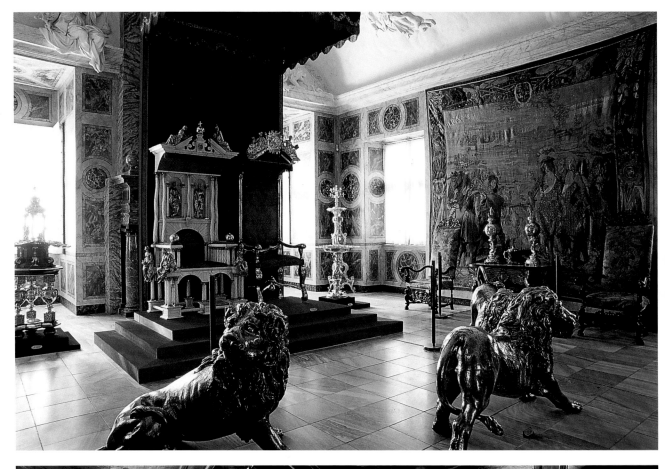

The public memorial halls of Rosenborg Slot remind us of all of the Danish kings who ruled between 1588 and 1863, beginning with the builder Christian IV. Where today people nod in remembrance, the Danish court once held lively parties.

Right page:
The royal garden of Kongens Have surrounding Rosenborg Slot is one of the city's loveliest parks. It has been converted back to its original Renaissance style and today is a popular meeting place of the populace.

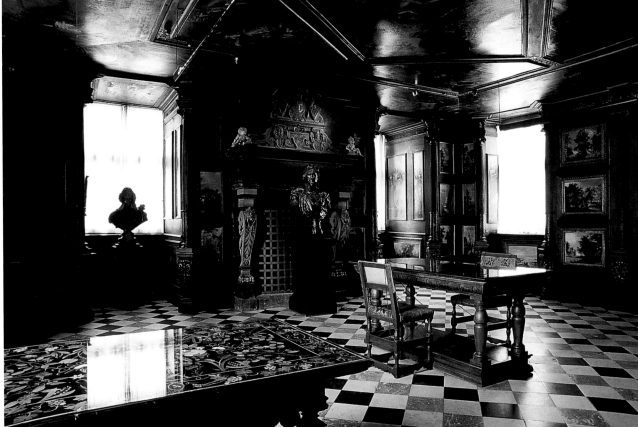

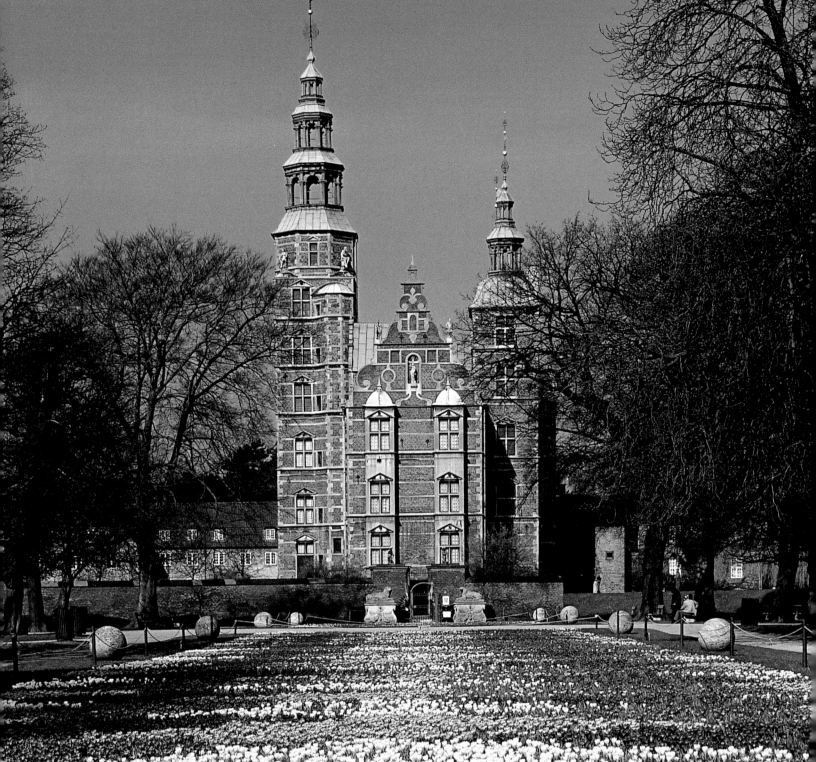

Denmark is a relatively sparsely populated country roughly twice the size of Wales. Yet, here we find hundreds of well-maintained castles, parks and manors; not only a sign of private prosperity and royal splendour, but also an expression of social duty to one's own history. The wealth of olden times is gone: woe to the Danish castle-owner who must satisfy all of the requirements of historic monument

protection, but only receives the meagre public subsidies! But necessity is the mother of invention: the traveller who is wooed by an increasing number of »slot« (castle) and manor owners as hotel guest profits from this. No fear of finery: some of these castles and manors are rather simply furnished.

Denmark's wealth of magnificent buildings is owed, like many other accomplishments, to King Christian IV. During only a few centuries of the Renaissance (c. 1550 – 1660) approximately 1,500 castles and manors rose across the country. Grand homes were put up during the Baroque (c. 1660 – 1730), and even Classicist times (c. 1775 – 1850), Denmark's »time of poverty«.

Most of the former and present royal castles are in and around Copenhagen: Rosenborg Slot (1624), for example, was originally a country seat but today is situated in the middle of the city. The castle park, the oldest royal park of Denmark, was transformed back to its original Renaissance style and since then has served – typically Danish – as a public refuge from the hectic life of the city of millions. Frederiksborg Slot in Hillerød is also acces-

Right:

It was burned down a number of times and in its present form has been the centre of political power in Denmark since 1928: Christiansborg Slot in Copenhagen's centre. Today the Folketing, the parliament, convenes here and the Supreme Court, ministries and the royal family's reception rooms are also housed in the castle.

Left:

The three-winged moated castle of Gammel Estrup on the Djursland peninsula is one of Jutland's loveliest Renaissance castles. Owned by the Skeel family for centuries, one can view magnificent legacies here, also from its other estates.

Page 39 top:

Only a few miles southeast of Næstved, Zealand (Sjælland), Gavnø Slot and its splendid parks welcome visitors. Inside one can view one of northern Europe's largest private painting collections, and outside the gorgeous flowers and plants of the castle grounds are renowned all over Denmark.

Page 39 bottom:

Compared to the magnificent furnishings of Rosenborg Slot, which holds collections of interiors, porcelain, silver and painting, the lifestyle of the family of Queen Margrethe II is quite secularly modest.

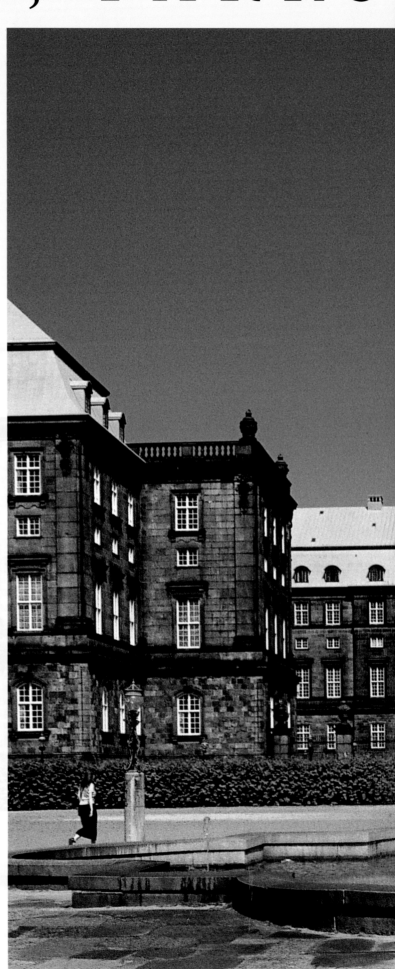

AND MANORS

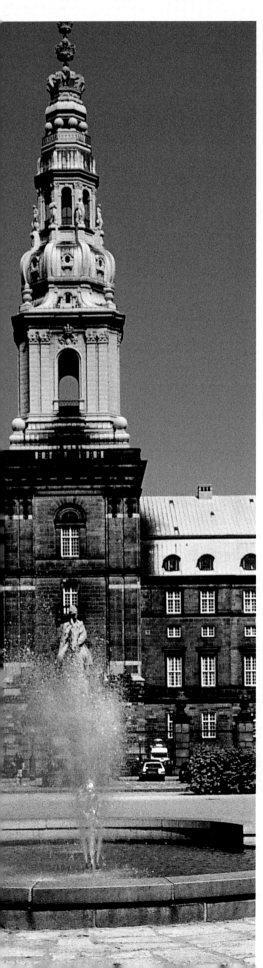

sible as the headquarters of the National Historical Museum. Only a few miles away in Fredensborg Slot, erected between 1720 and 1722 for King Fredrik IV on Esrum Lake, Queen Margrethe and her husband reside during the spring and summer months.

Dronninglund Slot and the estate of Børglumkloster in the north of Jutland and Schackenborg Slot by Tønder near the German border, the home of Prince Joachim and Princess Alexandra, are impressive reminders of the Baroque age.

The traditional Scandinavian openness

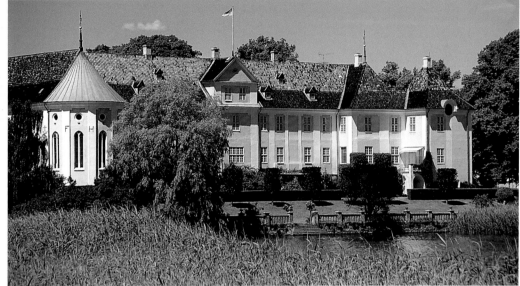

LABYRINTHS AND ROSE GARDENS

Egeskov Slot (1554) on the island of Funen is considered one of Europe's loveliest moated castles: next to the castle itself an extensive hedge labyrinth, the castle park with rose and herb gardens, and an antique car museum draw visitors in droves. Just a bridge-span away across the Svendborgsund lies Valdemars Slot (1644) on the Troense peninsula. The symmetry and sea-side location of the castle, built a bit out of the way by Christian IV for his son Valdemar, are captivating.

The power of the nobility and landowners during the Renaissance is most markedly seen on Jutland: on the Djursland peninsula alone the four castles of Katholm, Rosenholm, Løvenholm and Gammel Estrup testify to the wealth of individual families. Among the most beautiful noble seats of the Renaissance times is Voergård estate in the east of Vendsyssel, the »hood« of Jutland separated from the mainland by the Limfjord. The walls are adorned with relief sculptures and ornamented cornices; however, the wealth inside the castle, including paintings by Goya, Raphael, Rubens and Frans Hals, is owed to later owners.

between the royal house, politicians and nobility on the one side and the populace on the other side is manifested in generous accessibility to most parks, even when the castle or manor owners are at home. Therefore, local and regional cultural events increasingly include castles and manors in their programmes. One of the biggest events of this kind is the »Kulturhøst«, during which the cultural harvest is brought in every year in late summer on the islands Lolland, Falster, Møn and South Sjælland. Among others Gavnø Slot by Næstved, the Rococo grounds of Liselund Slot above the chalk cliffs of Møn, Corselitze and Fuglsang Park on Lolland serve as venues for concerts, exhibitions and events.

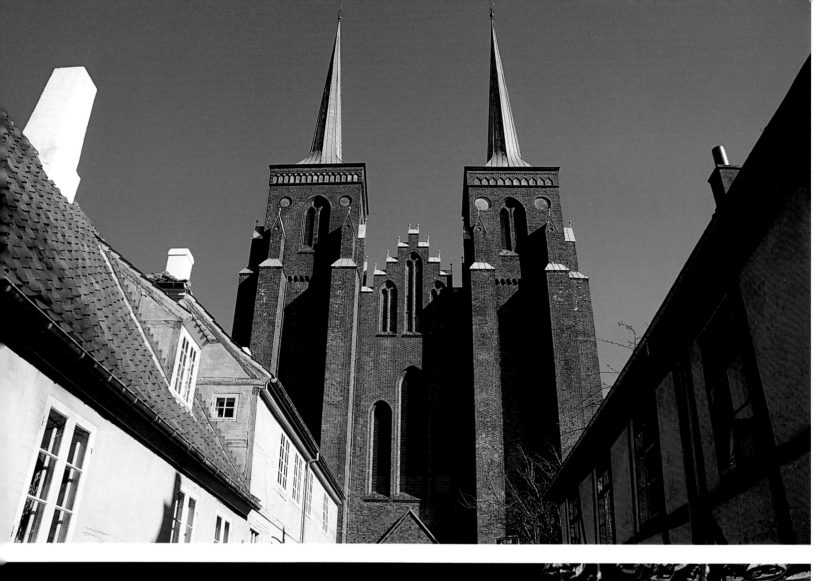

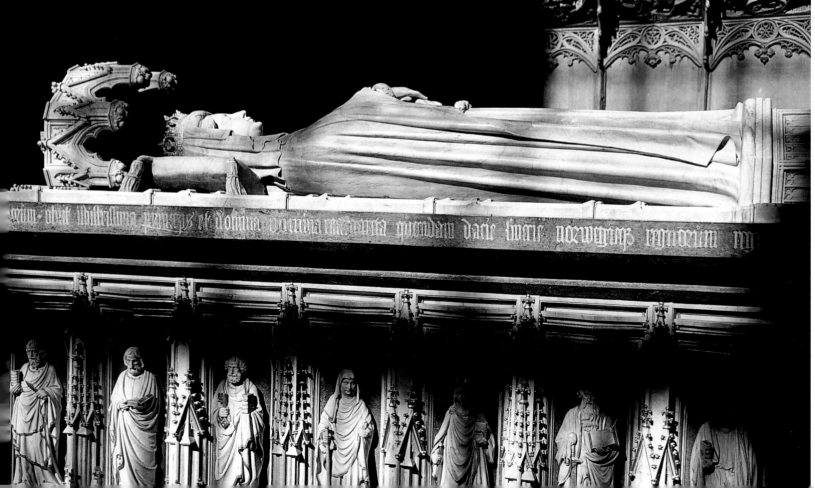

Left:
Until the 15th century the city of Roskilde on Zealand was one of the nation's most important power centres. One reason was that Roskilde was the seat of the bishopric and centre of Catholicism in Denmark. Visible from far and wide the pointed towers of the cathedral verify its importance.

Below:
All of the Danish queens and kings since the time of Margrete I (died 1412) were laid to rest in the cathedral. Chapels, memorial slabs, sarcophagi and commemorative plaques give the church interior its very unique atmosphere.

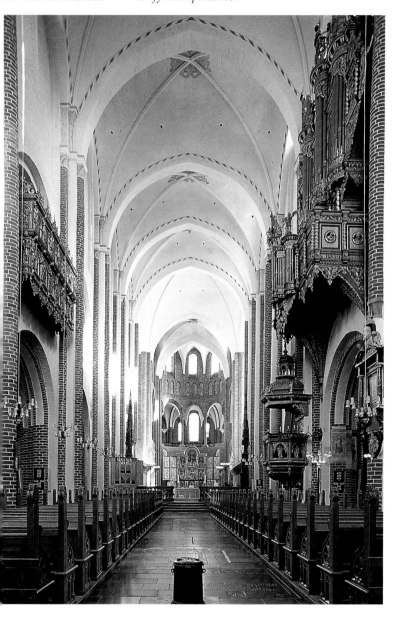

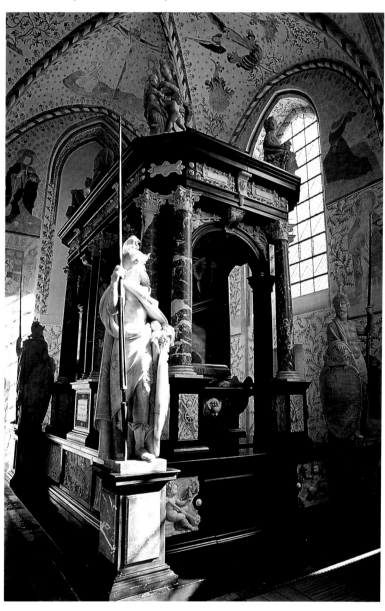

Left:
In 1397 Queen Margrete I united the nations of Scandinavia to one empire. Never again in its history did so much power lie in one hand. Her sarcophagus can be seen in Roskilde Cathedral.

Above left:
Roskilde Cathedral reflects almost two centuries of church architectural history, with its unique blend of Romanesque and Gothic elements. Ten further additions that arose over the centuries expanded the variety of styles accordingly.

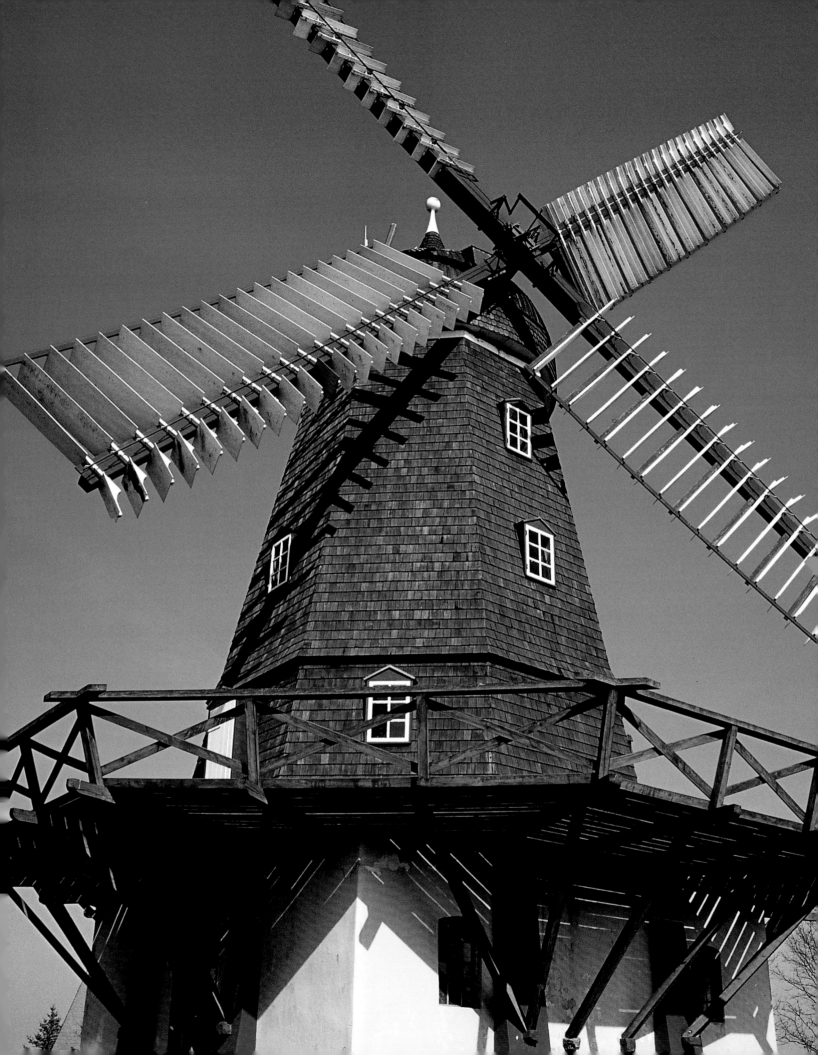

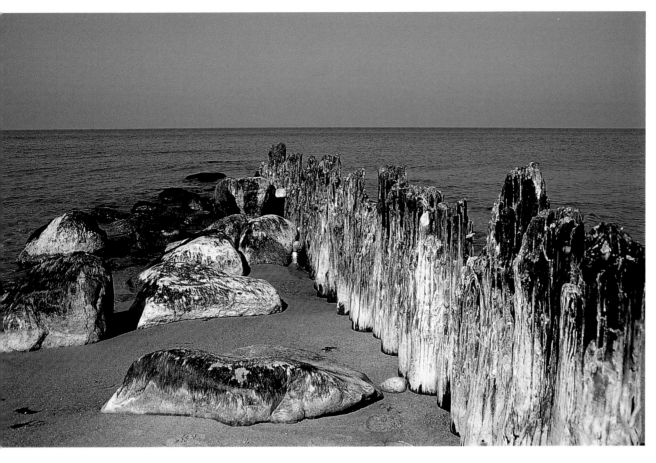

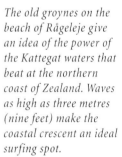

The old groynes on the beach of Rågeleje give an idea of the power of the Kattegat waters that beat at the northern coast of Zealand. Waves as high as three metres (nine feet) make the coastal crescent an ideal surfing spot.

With roughly 40 square kilometres (25 square miles), the Arresø in the north of Zealand is one of Denmark's largest lakes. It was formed by the moraine deposits of the last ice age that ended about 12,000 years ago.

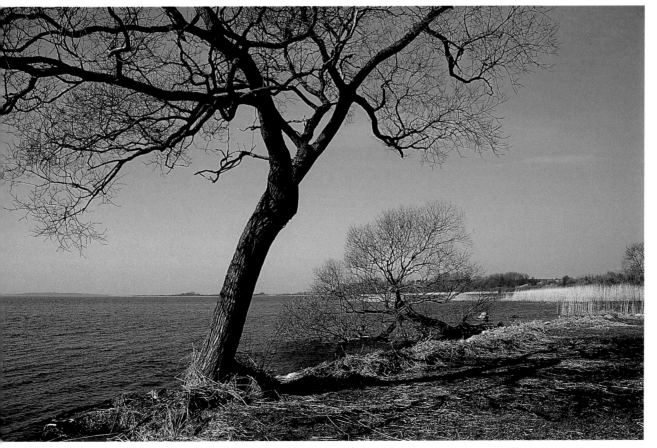

43

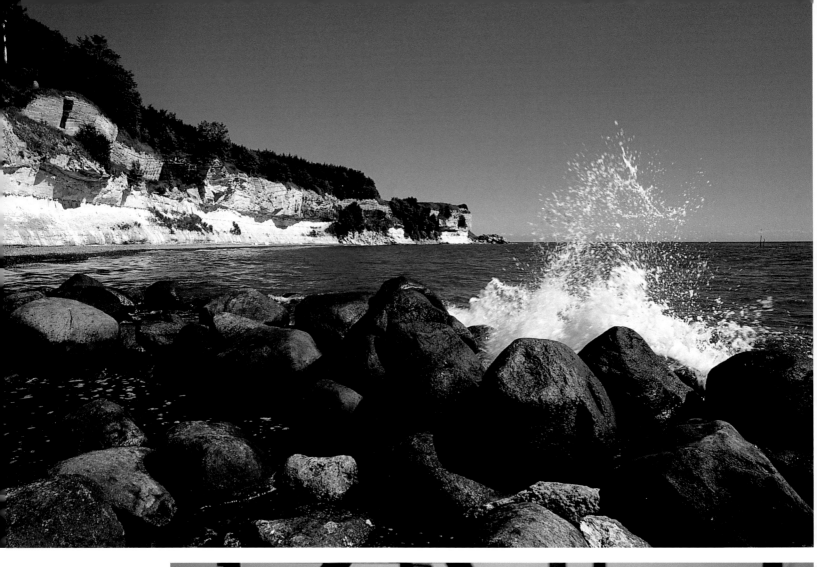

Above:
The up to 41 metre (135 feet) high chalk cliffs of Stevns Klint form the abrupt end of Zealand at the south-eastern end of the island. Their bottom layers are over 65 million years old and contain countless fossils of sea urchins, shells, fish and amphibians.

Right:
The Vikings' great skills in shipbuilding are revealed by the meticulous reconstructions of trading vessels built in the shipyard of the Viking Ship Museum in Roskilde. Once completed, the wooden boats offer journeys on Roskilde Fjord.

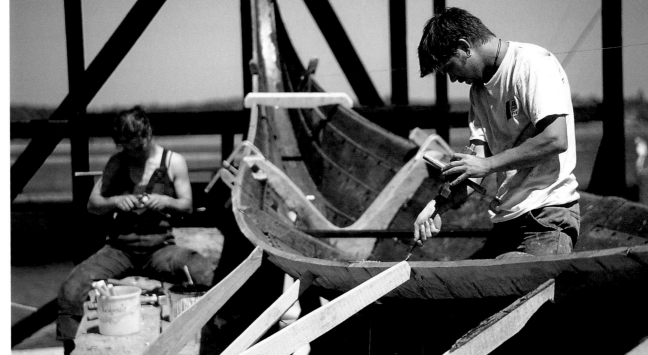

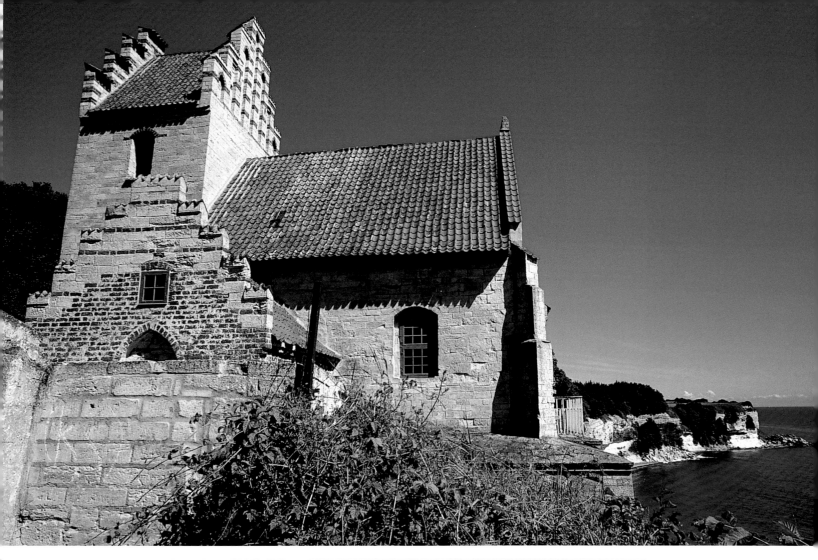

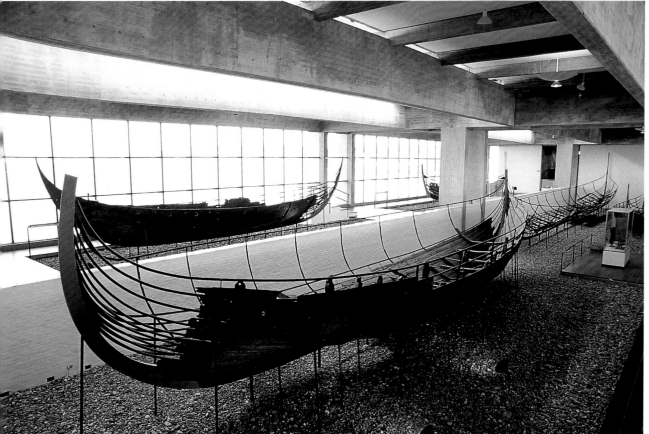

Above:
Its choir fell into the sea in 1928, the remaining parts of the Højerup Gamle Kirke are now reinforced and it has become a landmark of the chalk cliffs of Stevns Klint. Right next door the Stevns Museum presents regional history and folklore.

Left:
The impressive remains of the former longships and cargo ships of the Viking age can be seen at the Viking Ship Museum in Roskilde. The five roughly 1000-year-old seaworthy vessels were found in the early 1960s, about 20 kilometres (12 miles) to the north in the fjord.

Below:
A bit away from the busy ferry port, fishing trawlers are moored in the former shipyard basin of Helsingør. From here it's only a few steps to the powerful ramparts of the castle of Kronborg, which today serves as a sea-mark for Øresund (The Sound).

Above right:
Today we can traipse »in the footsteps of William Shakespeare« through the old lanes of Helsingør. The half-timbered houses, some 450 years old, still give us an idea of life in the harbour city when every passing ship had to anchor to pay the Øresund duty. Back then not all of the city's nooks and crannies were as fine as they are today...

Centre right:
Shakespeare brought Kronborg Slot world renown as the backdrop of his »Hamlet«. Most of the magnificent Renaissance castle, which has had its present appearance since 1585, is accessible to the

S.A.98

public. The extensive casemates are especially impressive: one of their niches holds the remains of Denmark's national hero Holger Danske, who the saga says will awaken again when the country most sorely needs him.

Below right: *The red of the churches and their characteristic stepped gables are typical for the eastern Danish islands, like here in Vester Egesborg. The Lutheran Church is today the national denomination and 90 percent of the population are members. Until religious freedom was declared in 1849, Danes who converted to Catholicism lost their civil rights.*

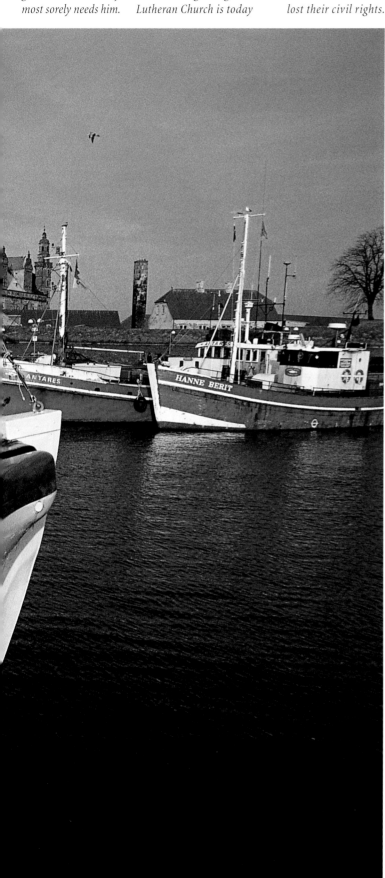

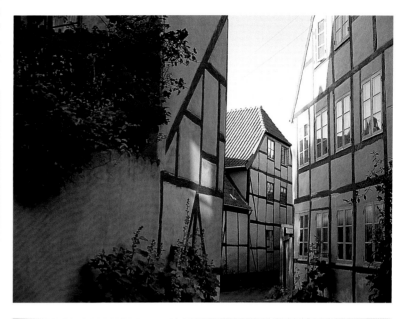

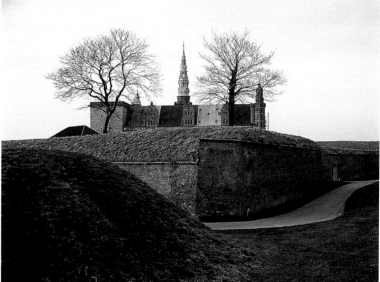

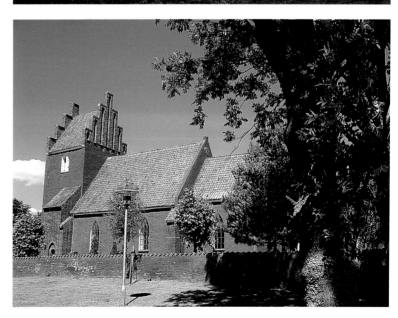

Below:
The red lighthouse of Helsingør stands on the port side to show the many ships between Denmark and Swedish Helsingborg which way to go.

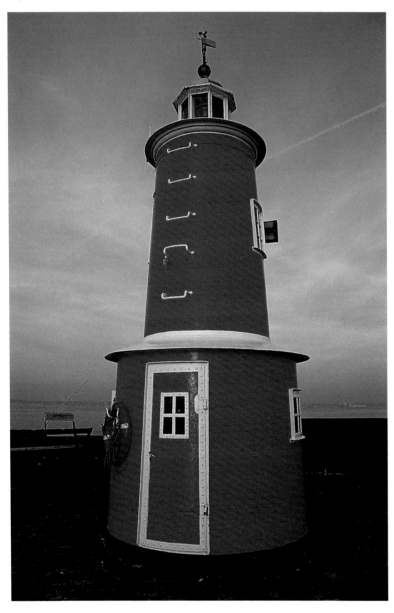

Right:
Heracles battles the four-headed Hydra in the harbour of Helsingør. The monumental sculpture was created by the Symbolist Rudolph Tegner (1873–1950). His other works can be viewed in the Rudolph Tegner Museum two kilometres (1.2 miles) from Dronningmølle.

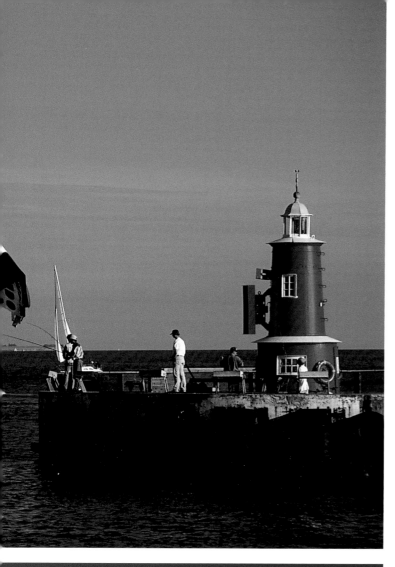

Left:

Every 20 minutes round the clock the modern double-ended ferries shuttle across the narrowest point of the Øresund here. The Øresund bridge between Malmö and Copenhagen has not slowed the ferry traffic between the sister cities of Helsingør and Helsingborg: many commutes are accompanied by an extended meal in the excellent ship restaurants.

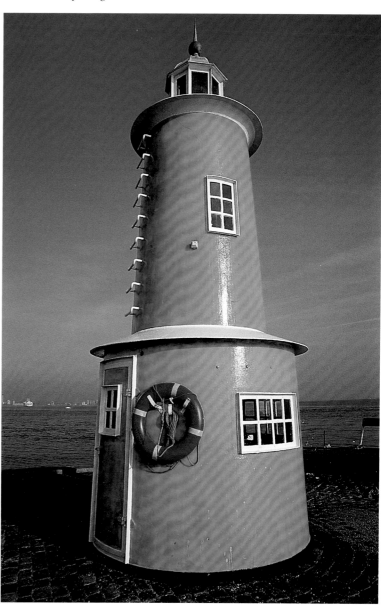

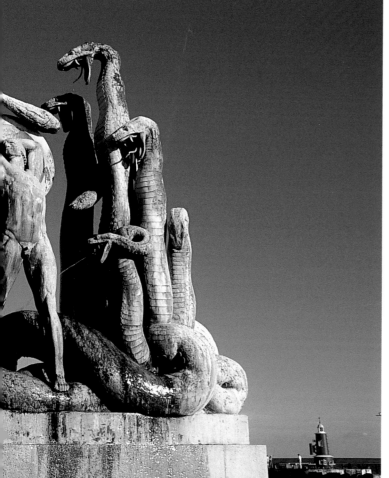

Above:

Green for starboard: the bright lighthouses at the entrance to the port of Helsingør show ships the way. Caution is prudent: with around 20 million passengers per year the ferry route between Helsingør and neighbouring Helsingborg is the most frequented route in the world.

One of the most-visited museums on Zealand is the estate of Rungstedlund, the home of the exceptional Danish literary figure Karen Blixen (Isak Dinesen). In spite of the many visitors the house has kept its quiet, haute bourgeoisie ambience in which Karen Blixen spent her Danish years here.

Idyllic as in the days of Hans Christian Andersen. In some villages of the little kingdom, like here in Gilleleje, time seems to have stood still; certainly lending it some of its unmistakable charm.

The fascinating view of the silver-grey of the Øresund is only one of the many sights that the Louisiana Museum of Modern Art has to offer. The museum building and grounds in Humlebæk, Denmark's quintessential art temple, is a work of art in itself. Nestled in the natural surroundings of the steep seacoast, its position alone is worth the visit.

Karen Blixen is kept alive in the authenticity of her house, where the interior has survived the passing of time without change. Every morning fresh flowers adorn the sunlit rooms of the estate, just as the Grande Dame of Danish literature loved it.

Small nations, small languages – it is the cross borne by the literature of every small country to have to move within a limited linguistic space, and this applies not least to the kingdom with the white and red flag. Only 5.2 million Danes, Faroers and Greenlanders master the Danish tongue.

So it is not surprising that Danish literature was long unfamiliar to the rest of Europe. Nor is it surprising that even the greats like Hans Christian Andersen and Karen Blixen are categorised under German or English literature. For long periods the intercultural impulses from south to north were too one-sided; very few writers found an ear south of the border.

One of the first was the master of the Enlightenment, Ludvig Holberg (1684–1754). The title »Molière of the North« is flattering, yet says something about the qualities of the great author of comedies who recreated uniquely Danish moods in stories such as »Jeppe of the Hill«. Rilke-lovers know that the German poet was greatly inspired by the naturalist Jens Peter Jacobsen (1847–1885) who also made an international literary mark with »Fru Marie Grubbe« and »Niels Lyhne«. Søren Kierkegaard (1813–1855) and Hans Christian Andersen (1805–1875) processed the early 19th century in the literature as differently as two people can see the world at the same time. Whilst the theologian and philosopher Kierkegaard became the founder of Existentialism in works such as »Either/Or«, complex Andersen's sensitive art of fairy tale telling make him Danish literature's »bestselling export« to this very day. His closeness to Chamisso, Tieck and the German Romantic paradoxically

Top left:
Karen Blixen on the grounds of Rungstedlund. This photograph from 1943 shows the author in her late fifties after her return from Africa to her familiar surroundings.

Above:
Not until »Out of Africa« was filmed did Karen Blixen posthumously achieve the world fame that her literary work deserved. This is no Hollywood movie; the fascinating mementos of her life on the African continent are real evidence of a breathtaking phase in her momentous biography.

Top right:
His marked social consciousness, gives Martin Andersen Nexø a special place in Danish literary history. His striking bust can be seen in front of his home in the small town of Nexø on Bornholm.

DANISH LITERATURE

led to Andersen's »Märchen meines Lebens ohne Dichtung« being first published in Leipzig. Not until eight years later was it published as »Mit livs eventyr« in Denmark. Marked by the enormous technological and industrial developments of the late 19th century, Hermann Bang (1857–1912) and Martin Andersen Nexø (1869–1954) studied the quiet lives on the edges of a greatly changing society in very different ways. The formidable filming of »Pelle the Conqueror« by Bille August just recently brought the Bornholm native Andersen Nexø to new international fame.

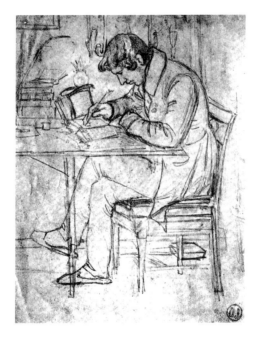

THE GRANDE DAME OF SCANDINAVIAN LITERATURE

In the frenzy of world wars and the social upheaval of the years between the wars Denmark's literary figures kept much to themselves. Only Karen Blixen (1885–1962), known in English-speaking countries as Isak Dinesen, attained her international breakthrough in the 1930s with »Seven Gothic Tales«, which was originally written in English and first published in the United States. But the life and work of the Grande Dame of Scandinavian literature became familiar to the broader public only much later through the film based on her autobiographical novel »Out of Africa«. Her former home, Rungstedlund estate on the Øresund coast to the

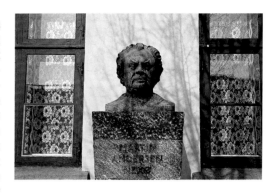

north of Copenhagen, is today one of the most-visited museums of Denmark and the centre of literary life.

Fiction, political criticism, confessional poetry – in the 1950s and 1960s a colourful literary world arose, in which the first multimedia artists often worked in a number of genres at one time. Klaus Rifbjerg's (1931–) »The Chronic Innocence« which focuses on the generation of war children in the search for a new identity became a cult novel in 1958. Twenty years later, with his polemical treatise »Revolt at the Centre«, Villy Sørensen put the value system of Danish society up for public debate. The Frankfurt Book Fair of 1990 was a turning point for Danish literature by awarding authors such as Peer Hultberg and Inger Christensen great international acclaim. But the new star of Danish writers is Peter Høeg (1957-), with his novels »Borderliners« and »Miss Smilla's Feeling for Snow«. The few who didn't read the latter may have seen the film based on the Danish-Greenlandic crime thriller, which pushed previously unfamiliar issues of Danish society into the focus of cultural interest in our Nordic neighbour.

Centre right:
Søren Kierkegaard as a hard-working student. The theologian and philosopher dealt primarily with the status of the individual.

Bottom right:
Somewhat sceptically, Hans Christian Andersen gazes over the Copenhagen Town Hall marketplace. But Denmark's capital city certainly proffered the egocentric, multitalented man the attention he desired.

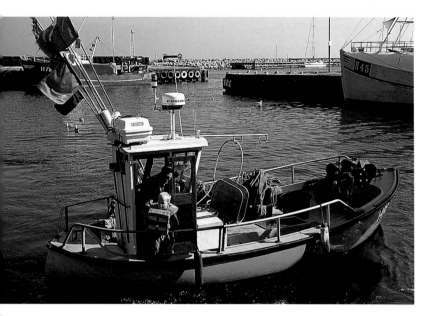

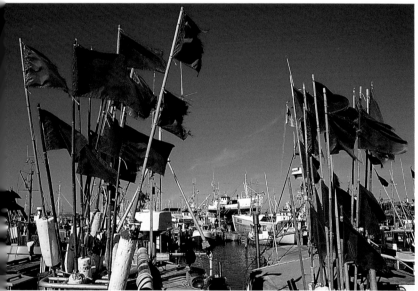

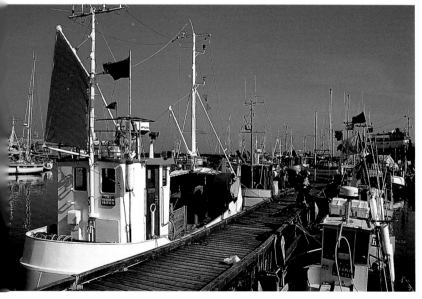

Small photos left:
Gilleleje on the northern point of Zealand is one of Denmark's oldest fishing villages – although the hubbub of the harbour is more urban.

Every morning a large, public fish auction is held here, from which Copenhagen's best chefs also procure their fresh seafood wares. But fishing quotas and growing vessel operating costs contribute to the over-proportionally high unemployment rate of Denmark's fishers.

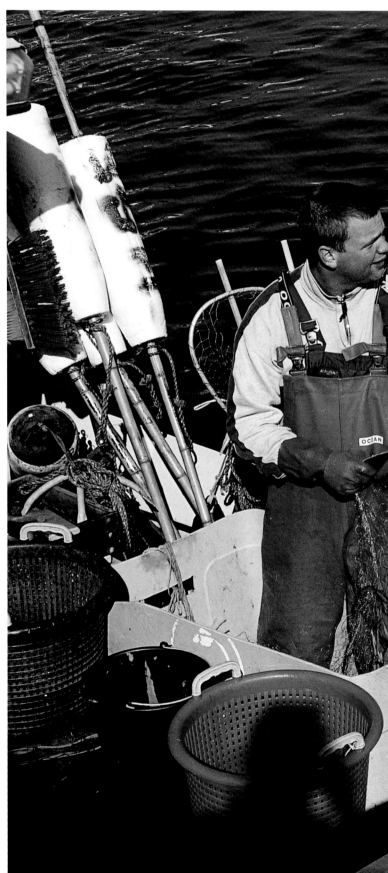

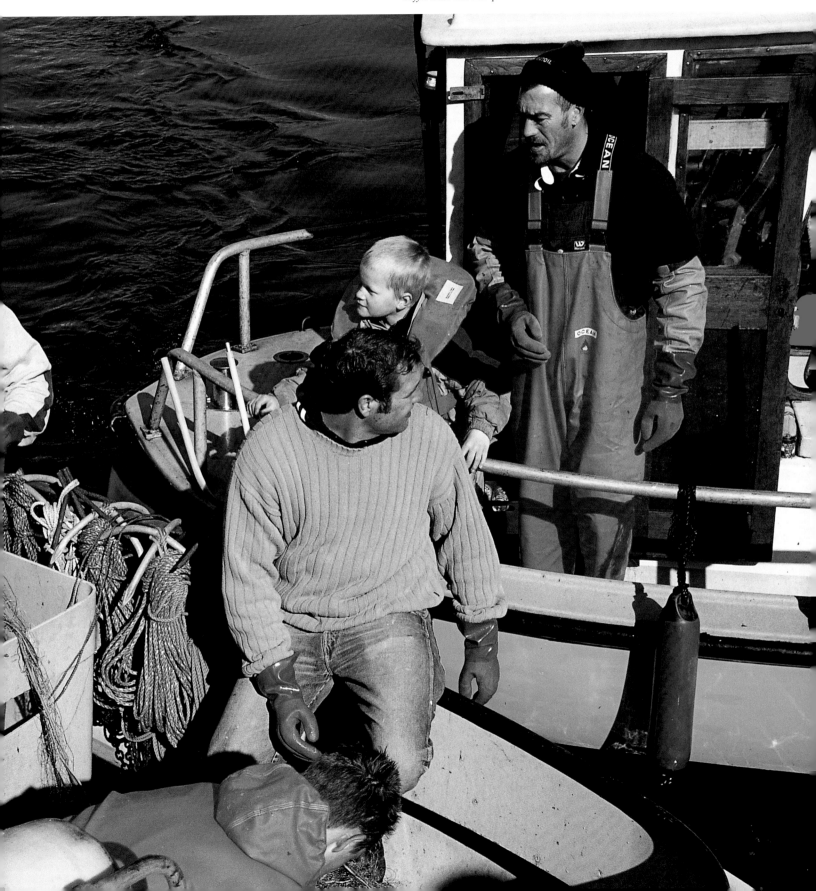

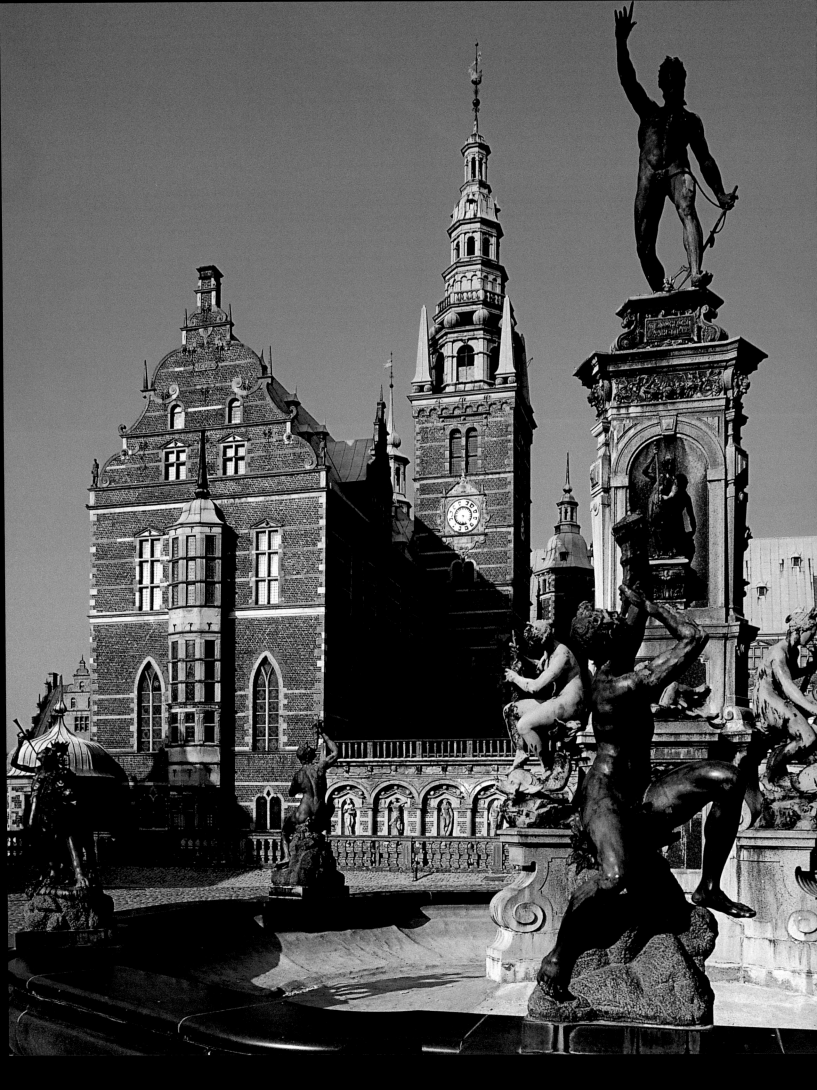

Left:
Frederiksborg Slot in Hillerød presents itself in the loveliest Dutch Renaissance style. The splendid castle of Christian IV, built between 1600 and 1620, today houses the Museum of National History. One of the greatest sights of the fanciful complex is the organ of the castle church built by Compenius in 1610.

Below:
Fredensborg Slot in the town of the same name on Esrum Lake commemorates the peace (fred) that followed the Great Northern War. Baroque, Rococo and Classicism are represented in the architecture of the palace completed by Fredrik IV in 1722. Today Fredensborg Slot is the summer residence of the Danish royal family.

Below:
Between Fredensborg Slot and the shores of Esrum Lake lies one of Denmark's loveliest gardens. The palace park is opened to the public year-round, in contrast to the palace itself that can only be visited in the month of July.

The marble garden of Fredensborg Slot is adorned by countless statues, vases, columns and amphora. Gifts to the royal family constantly increase the collection.

The moated castle of Frederiksborg boasts a magnificent French Baroque garden from the year 1720. All of Denmark's absolutist kings were crowned in Frederiksborg's castle church between 1761 and 1840.

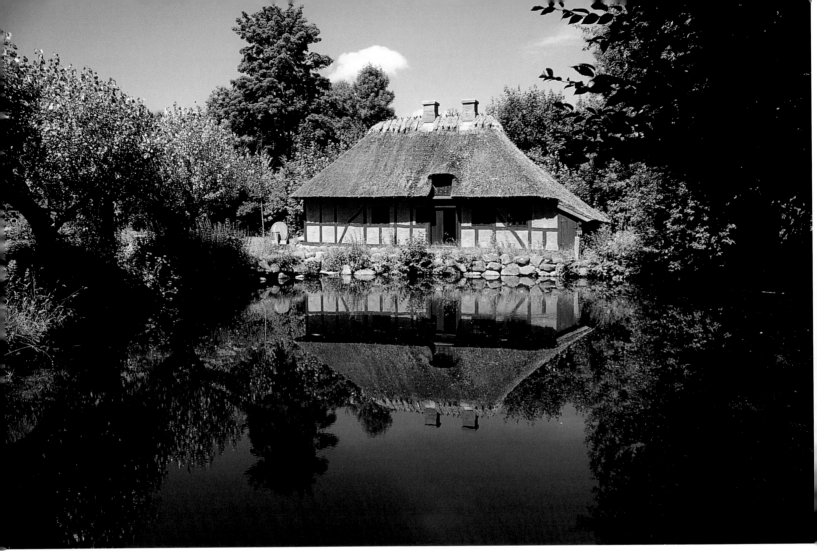

Above:
Sorgenfri (roughly »worry-free«) Slot, a former summer residence of various monarchs, is situated slightly north of Lyngby. Right next door the open-air museum of the same name offers a representative cross-section of the centuries-old construction history of northern Zealand.

Right:
As in olden days hollyhocks adorn the walls of the little nameless cottages so typical of the country. This is not a museum; inside all the attributes of a modern Danish high-tech household are sure to be found.

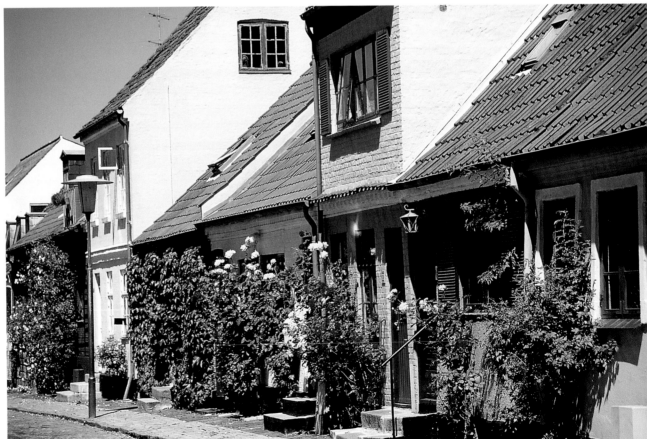

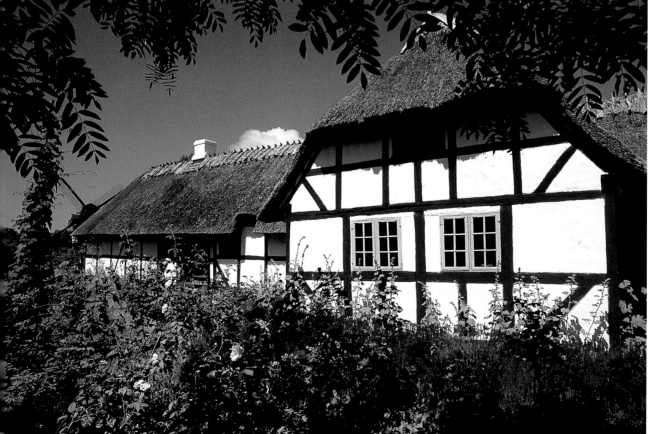

Above:
The summer residence of
Liselund nestles tran-
quilly in a corner of its
palace garden on the
island of Møn. The park
complex high above the
chalk cliffs is a romantic
homage to the French
»joie de vivre« of the
later 18th century.

Left:
The Sorgenfri open-air
museum on Zealand has
not only a complete vil-
lage with houses dating
from 1880 to 1960, but
over 70 complete farms
from all regions of Den-
mark, some of which still
keep domestic animals.

Below:
The church of Elmelunde, parts of which date from the year 1080, is among Denmark's oldest churches. Centrally-located on Møn it contains some of the country's »national treasures«: limewash paintings from around 1480.

Above right:
The triple-nave cathedral of Maribo on the island of Lolland, built around 1470, was once a cloister of the Brigittine order. It was made the collegiate church of the newly established bishopric of Lolland-Falster in the early 19th century and since 1924 has been the official cathedral church.

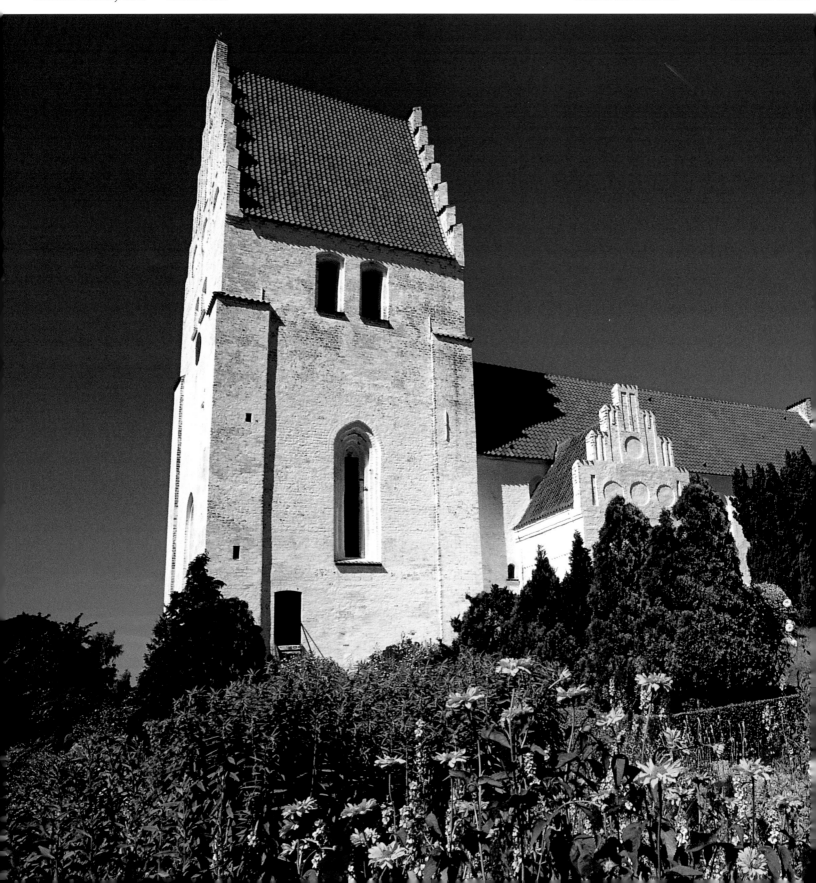

Centre right:
The church of Rørvig shines in bright colours reminiscent of Lego bricks. Typical for Denmark's churches: the stepped gables.

Below right:
Biblical motifs are portrayed on the ceilings of the church of Kelby in a fascinating narrative manner. The limewash paintings largely by the Elmelund master were meant to make the illiterate familiar with the stories of the Bible.

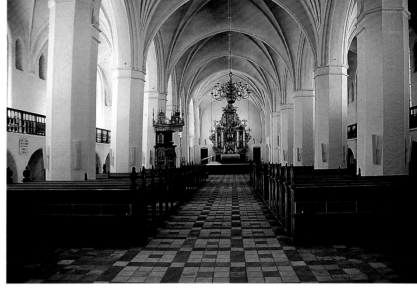

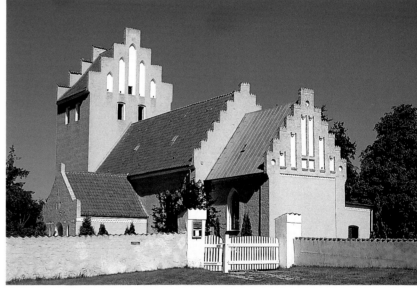

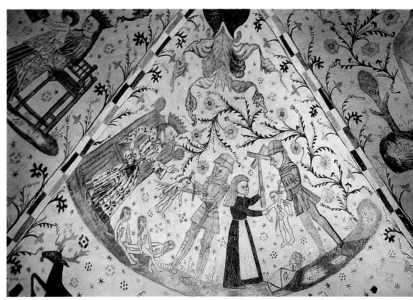

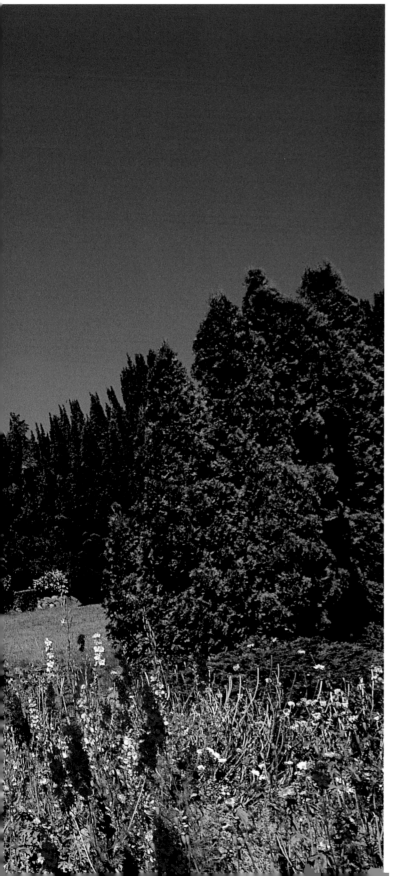

61

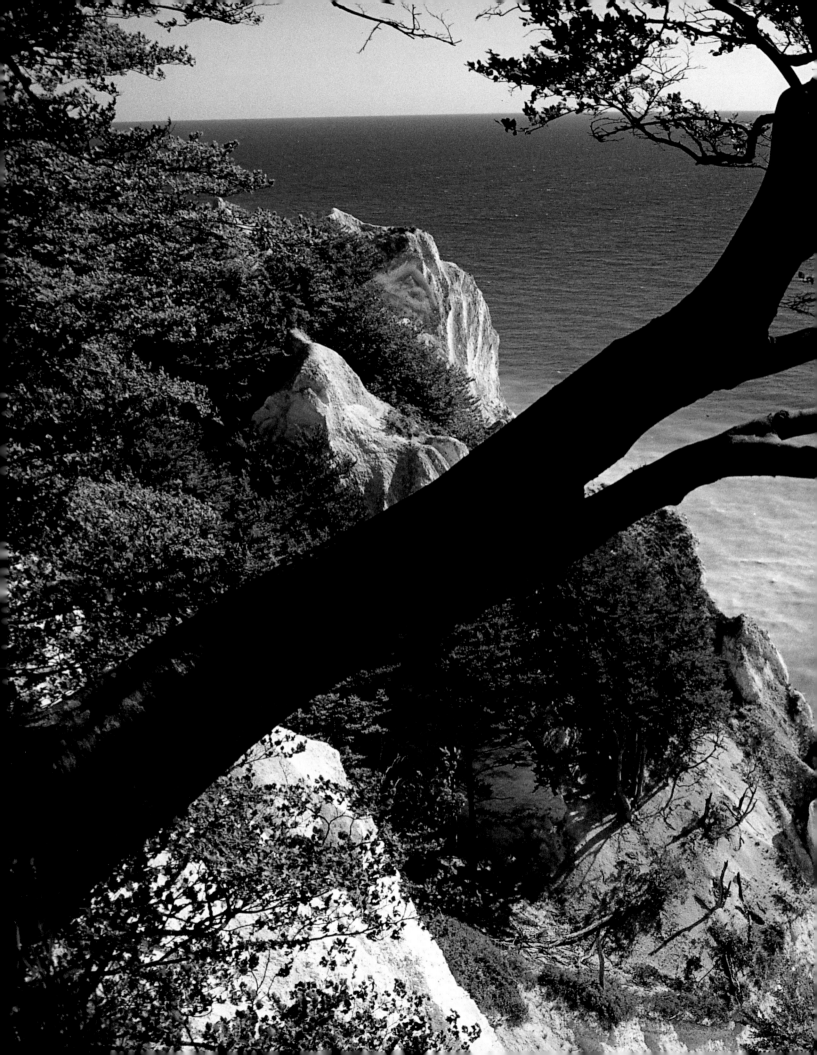

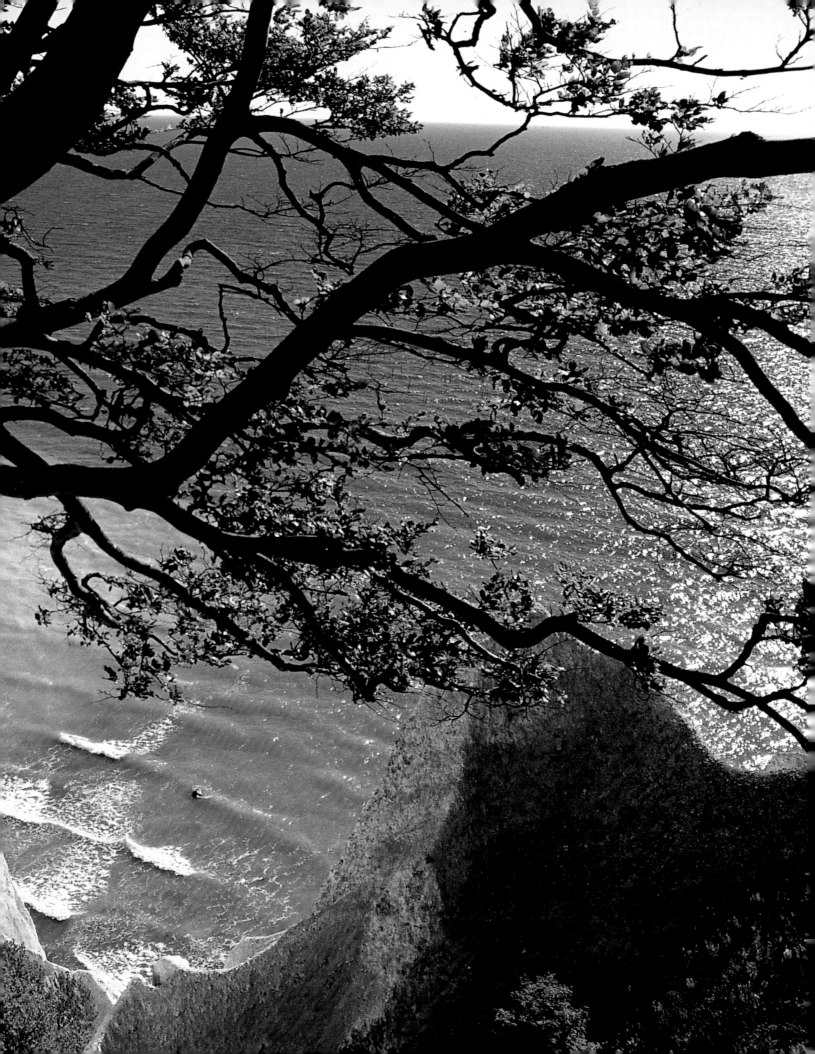

Pages 62/63:
The 75-million-year-old magnificent chalk cliffs of Møns Klint tower above the Baltic Sea. Twelve kilometres (7.4 miles) long and up to 128 metres (420 feet) high they form the steep eastern shore of the most easterly island of Denmark besides Bornholm. The variety of fossils found here is legendary. A number of pathways lead down to the beach but may be closed off in sections since the wind and weather take a toll on the white crags.

Right:
No house in Denmark is farther than 55 kilometres (34 miles) from the sea, and many Danes have their own little boat moored somewhere. The quiet dawns and sunsets on the water are a part of seaside life.

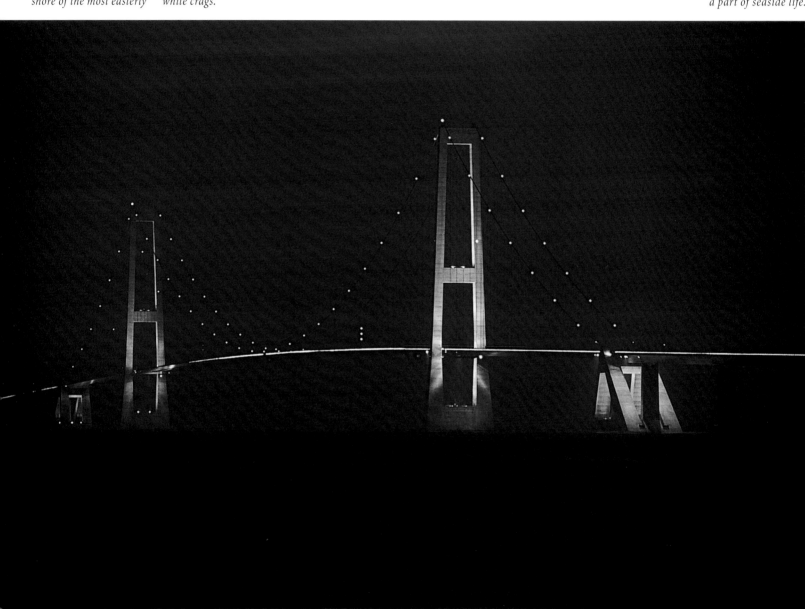

Above:
It changed life in Denmark like no other structure – the bridge over the Great Belt (Store Bælt) connecting Funen and Zealand.

But, the approximately 18 kilometre (11 mile) long masterwork of engineering is only a part of the crossing: while automobiles roll over the suspension bridge, the DSB trains roll through a tunnel below the waters of the Great Belt.

Right:
Even though Denmark lies in the very south of Scandinavia, evenings in the summer months are remarkably brighter than in Central Europe – while the incomparable light of the North almost unnoticeably generates peace and relaxation.

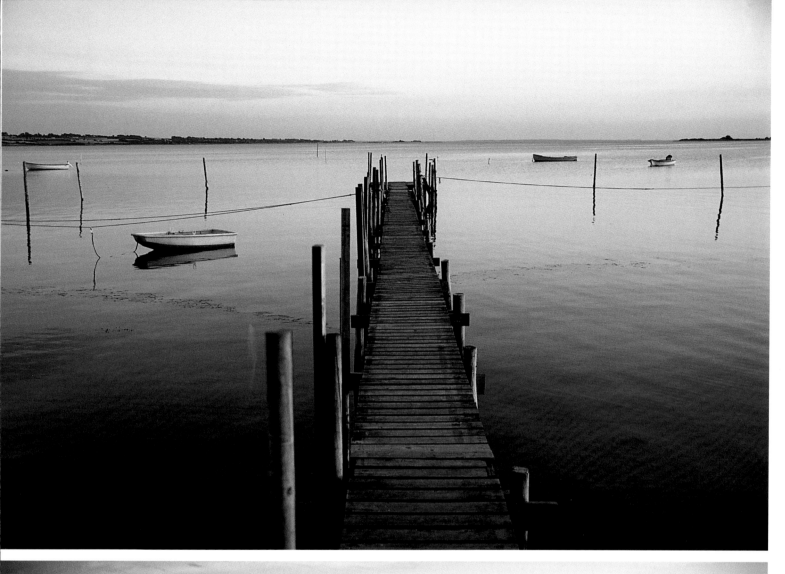

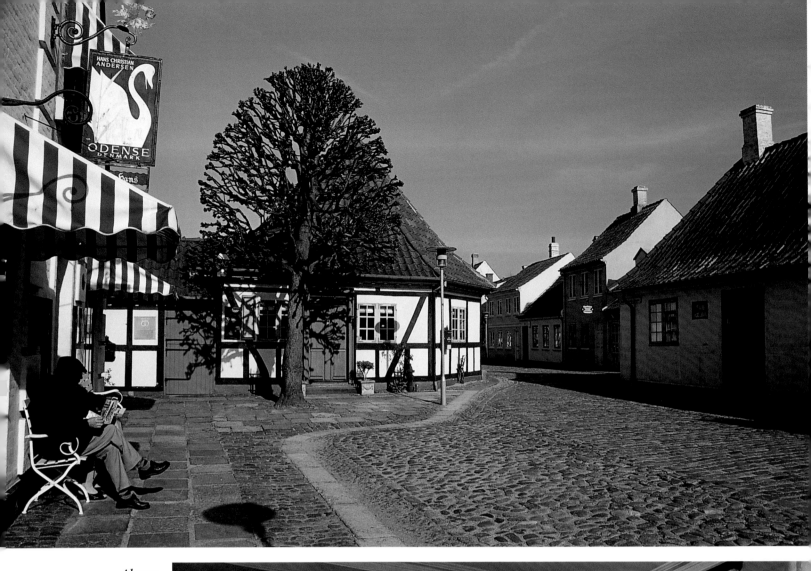

Above:
The Hans Christian Andersen Museum is like a dollhouse in the midst of the busy streets of Odense. Today it all looks quaint and tidy, but in former times it was the poor district of the city: Hans Christian Andersen spent his life trying to escape from this milieu.

Right:
When Andersen died in 1875 he was a wealthy man who was able to lead an upper middle class life. But, the Andersen Museum reminds us that Andersen stood up for the socially disadvantaged throughout his life.

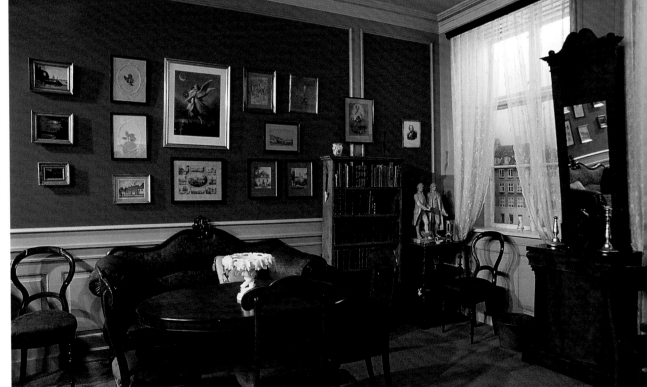

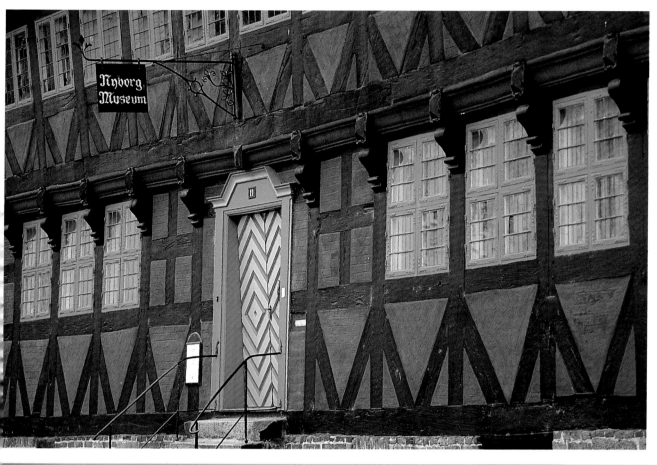

Left:
The Mads Lerches Gård, a mayoral courtyard from 1601 in Nyborg on Funen, today is the headquarters of the Nyborg og Omegn Museum of local history. The architectural jewel is among a whole series of half-timbered houses near the castle complex.

Below:
Until Copenhagen was made the royal capital in the year 1413, Nyborg Slot, situated on the eastern coast of Funen, was an important factor in the nation's political intrigues. Whatever the king, nobility and church decided during their annual assemblies was of constitutional force. The interior of the castle is rather plainly furnished.

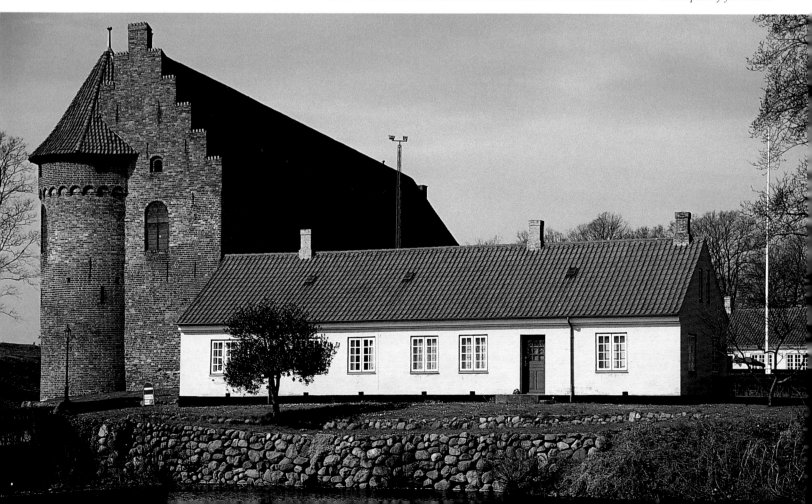

Below:
Egeskov Slot, located about 25 kilometres (15 miles) south-east of Odense, is considered one of the most beautiful Renaissance moated castles of Europe. Its

present appearance dates from 1554. The patterns of the well-maintained outdoor complex, which also has a bamboo maze, remind one of the gardening arts of the French monarchy.

Above right:
Horne Kirke is one of Denmark's most unusual sacred buildings. Its »core« is one of the country's seven round churches,

four of which are on Bornholm. A number of additions and towers added over the centuries give it its unique appearance today.

Centre right:
Originally Christian IV planned the castle Valdemars Slot, built between 1639 and 1644, for his son Valdemar Christian. But ownership of the castle on

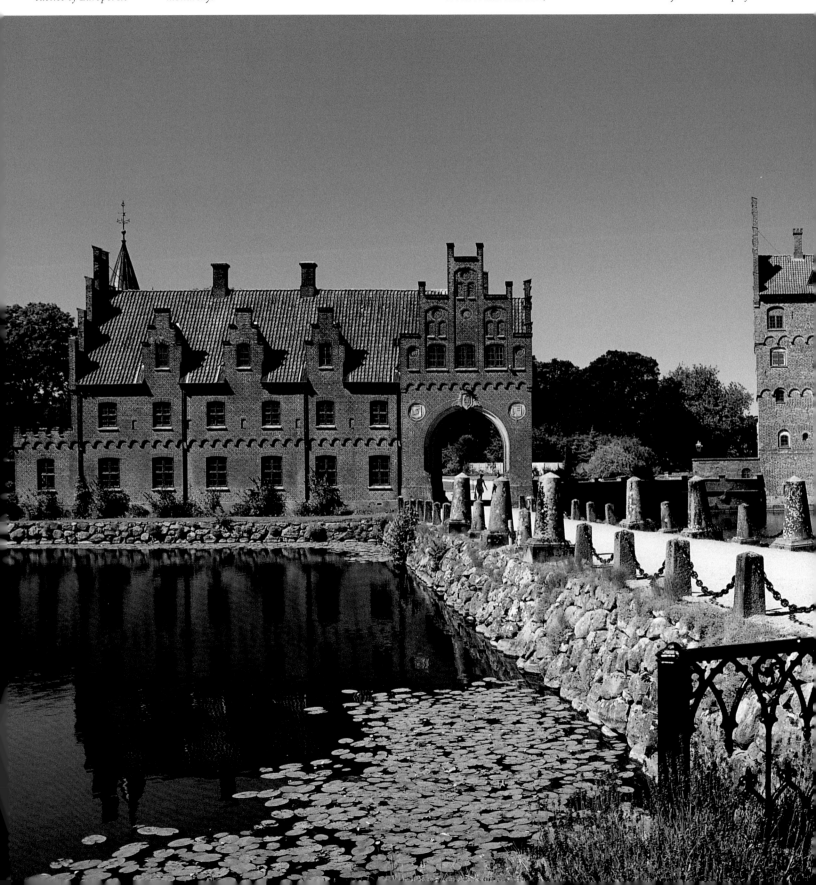

Tåsinge went in 1677 to Admiral Niels Juel. The splendid Baroque grounds, most of which are open to the public today, were designed under his grandson's supervision from 1754 to 1756.

Below right: The church of Gudme on Funen. Its huge dimensions, numerous archaeological finds from the time of the Romans and about 2,000 graves from between 100 and 400 BC reveal that the village was once far more important.

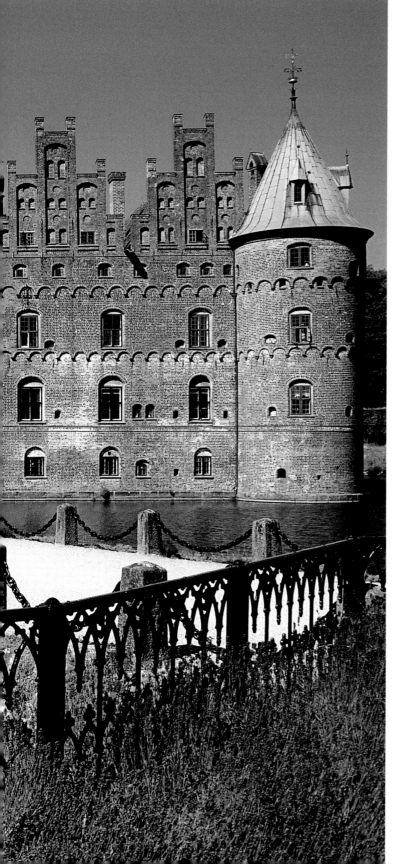

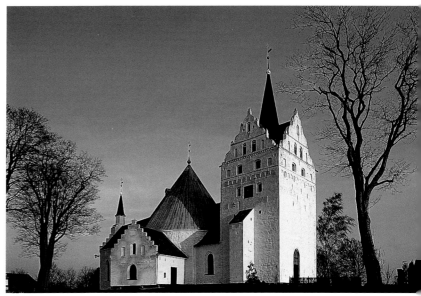

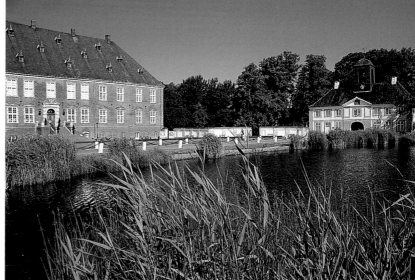

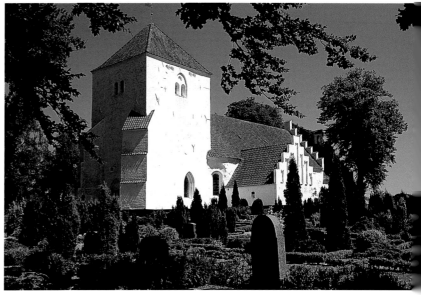

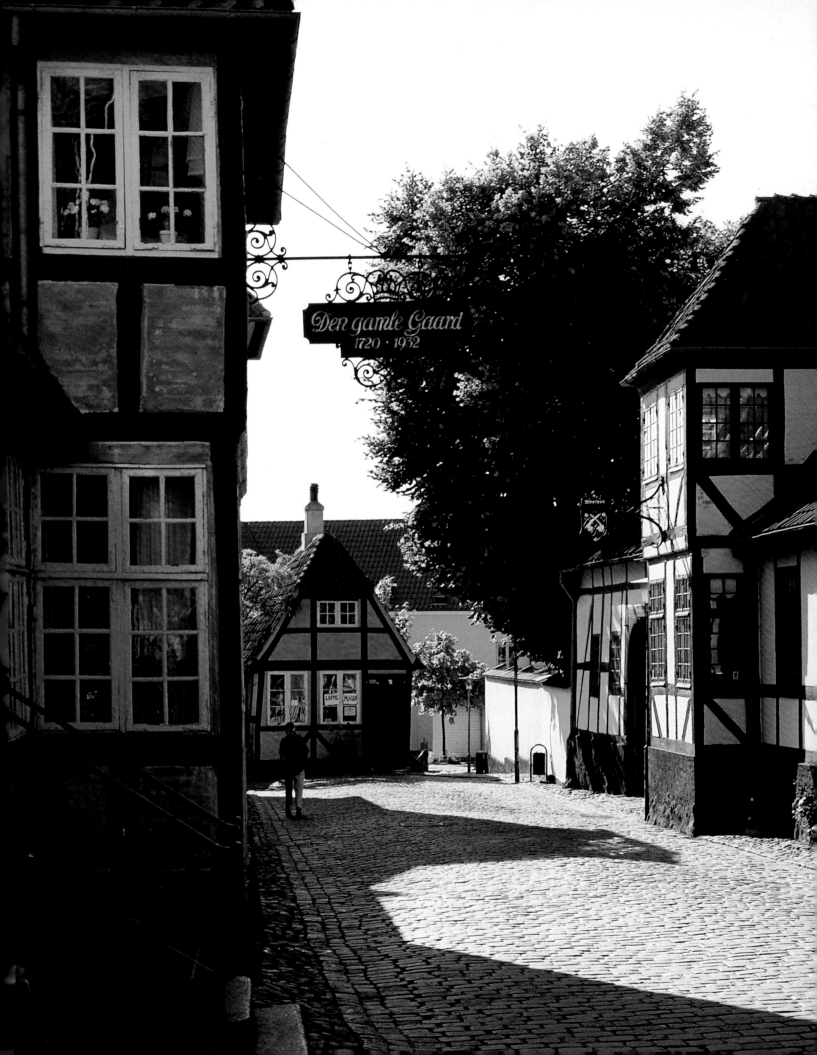

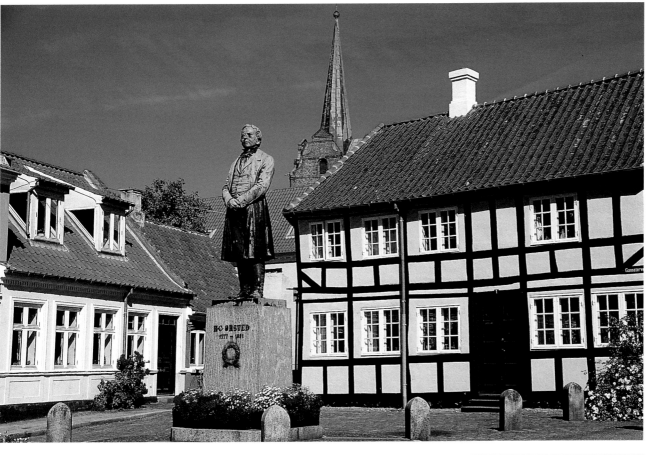

Left page:
The picturesque appearance of the traditional city of trade and seafaring, Faaborg in the southwest of Funen, is due to the lucky fact that the great fire of 1728 spared some districts entirely. Today Faaborg is a vital ferry harbour for the little islands of Avernakø, Bjørnø and Lyø.

The most famous historical personage of Langeland is undoubtedly the physicist Hans Christian Ørsted, who discovered electromagnetism. The island honours its world-famous son, born here in 1777, with a statue on the market square of Rudkøbing, Langeland's capital.

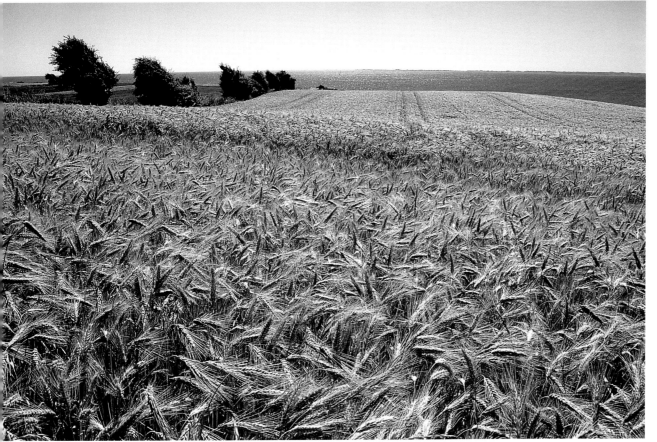

There is an extensive view over the hilly farming landscape of Ærø. The 88-square metre (950 square feet) island closes off the Danish South Sea to the southwest. Ærø is considered »Denmark en miniature«, since its reed thatched houses, little villages and the fresh colours of the fields, forest and the Baltic Sea wonderfully correspond to the cliché ideas of Denmark.

The old town of Ærøskøbing, the island capital, is like a living museum of the 17th and 18th centuries: picturesque cottages, winding cobbled lanes, abundant hollyhocks and people whose pace is two gears slower than today's usual, lend the town fascinating serenity.

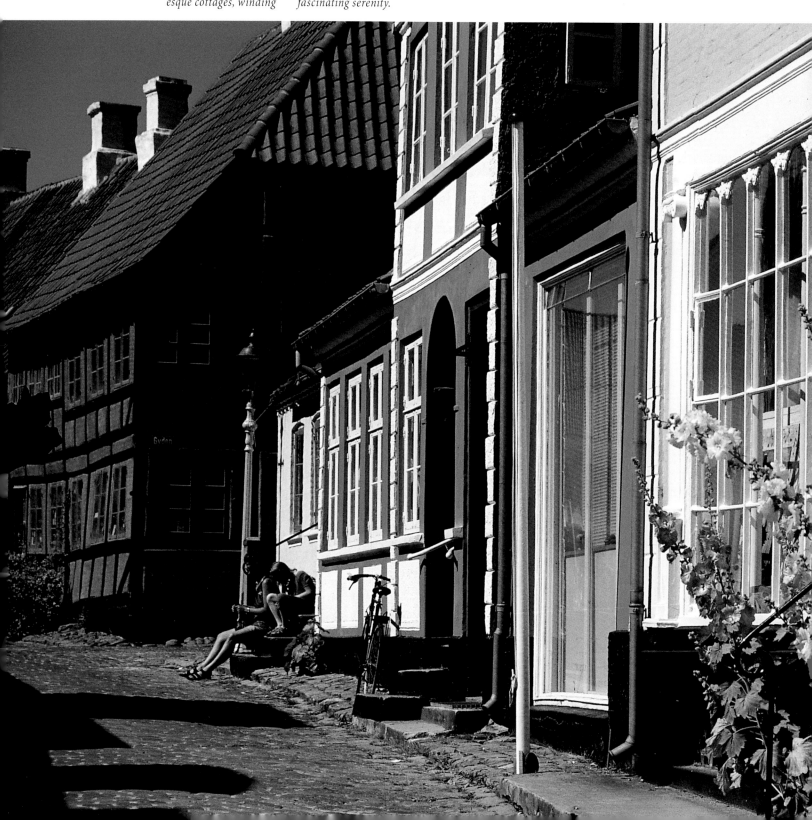

Small photos right:
Each of Ærøskøbing's well-maintained, half-timbered, 17th and 18th century houses are a little treasure chest in themselves. With an eye for details, every stroll through town can become a longer hike through the architectural history of the times when seafarers and merchants ensured the island's great prosperity. Situated at the very edge of Denmark, the picturesque isle is not nearly as economically powerful today.

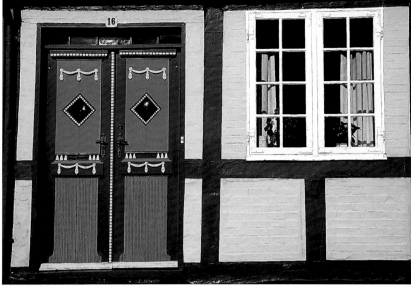

KØBMAND, KIRKE, KRO

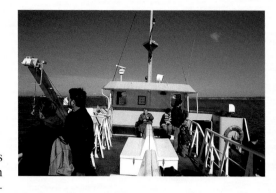

They have names like Lyø, Bjørnø and Mandø, they all lie in view of the mainland yet are each a universe in themselves – the smallest of Denmark's approximately 100 inhabited islands, which, like small, bright spots of colour, give the Danish waters the charac-

ter of a navigable inland sea. The people who live here were either born here or seek the intimacy of a small, closed society, often made up of only seventy or eighty neighbours. They have to live with the fact that their daily routine is decided by the ferry schedules to the mainland and not by their own temperaments. It's not merely a matter of the daily commute to work and back, but of the daily newspaper, bread and wine. It's a matter of the visitors who usually come on foot or bicycle to enjoy a few hours in long-lost idyllic surroundings that are just around the corner – and after enjoying the charms of the village island are glad to get back to their own self-determined lives in the evening.

Without the ferries Denmark's microislands would be doomed, making it unsurprising that all of the decisions pertaining to the lifeline to the mainland have utmost political priority. Just one journey less per day can wreak chaos on the daily routine of an entire island – and most visitors have no idea that their island excursions are an essential contribution to the extremely sensitive economies of the ferry operators. The Danish government sets great store in preserving the typical nation-

al island communities, making it more generous in economisation measures than may be economically wise. This affects all areas of life, perhaps not as drastically as in earlier days when the three K's – »købmand«, »kirke« and »kro« (merchant, church and pub) – were indispensable for a workable and functioning community. Today some islands peacefully share a pastor with the neighbouring isle without it damaging the islander's souls. It gets more complicated if the »købmand« goes out of business, so it goes without saying that the island inhabitants do not purchase all of their necessities at the cheaper mainland supermarkets, but from their own shopkeepers.

»DE DANSKE SMÅØER« – UNITED WE STAND

According to the motto »united we stand« 27 of the smallest Danish islands joined to form »De danske småøer«, giving them a louder voice when dealing with the Danish parliament or Brussels committees that decide on essential subsidies. But in spite of many common problems and demands, each island has its own history and viewpoint. Most of the small islands are situated in the »Danish South Sea« – the triangle formed by their much larger sisters Funen, Æro and Langeland. The tranquillity of this popular sailors'

Far left:
Leave the car on land: many of the small Danish isles cater to day-trippers who can easily rent a bicycle. Cycling is the mode of transportation that best suits the island pace.

Top left:
People know each other on board the little island ferries, which take anywhere from five minutes to two and a half hours for their crossings.

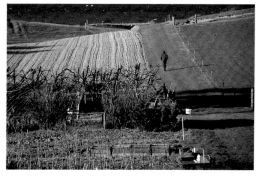

terrain is not very noticeable, for example, on Mandø. Its battle against the natural forces of the North Sea, which make it only accessible at low tide with high-wheeled carts, is just as much a challenge for the 70-soul isle as safeguarding an intact island community.

The ferry needs only five minutes to reach the island of Fur in the Limfjord from the mainland – long enough to make Fur a sparsely populated reservation in the middle of the country. Another geographical exception among the small islands is Anholt, situated in the middle of the Kattegatt between Denmark and Sweden. At a distance of two and a half hours by high sea ferry from Grenaa, the people of Anholt feel like an exotic outpost of their nation, though the island has developed into a tourist draw due to its exposed location, marvellous sand beaches and marina. But the relative hubbub of the sailors and campers quiets down quickly when the end of August rolls round – leaving the inhabitants to themselves, as on the other islands. At the »købmand«, in the »kirke« and of course at the »kro«.

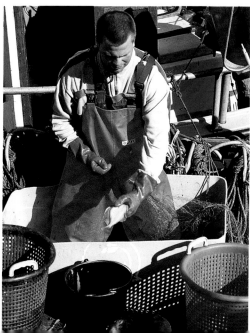

Bottom left:
Here comes the ferry! The rhythm of the ferry timetable determines the daily routines of the island inhabitants.

Above:
With the exception of Mandø, all of the inhabited small islands of Denmark lie in the Baltic Sea or in the Limfjord. Almost every household has its own little boat.

Top right:
The landscapes of the Danish South Sea islands roll gently. Hardly any of the farmers could survive without the EU subsidies.

Right:
Many island inhabitants make their livings as small fishermen – their neighbours are also their direct customers.

Right:
Leaving the harbour of Søby. The small town in the northwest of Ærø is the third harbour town of the island besides Marstall and Æroskøbing, and is visited regularly by ferries.

Below left:
The beach at Marstall is one of Ærø's most popular swimming spots. Here the Baltic Sea is open to the east, often making for good surf. Incidentally, all of the beaches on Ærø have the blue flag, certifying the best water quality.

Below right:
The Danish South Sea, as the waters south of Funen are called, is one of the best sailing waters of the entire Baltic. The narrow sounds and passages often require great skill of even experienced skippers.

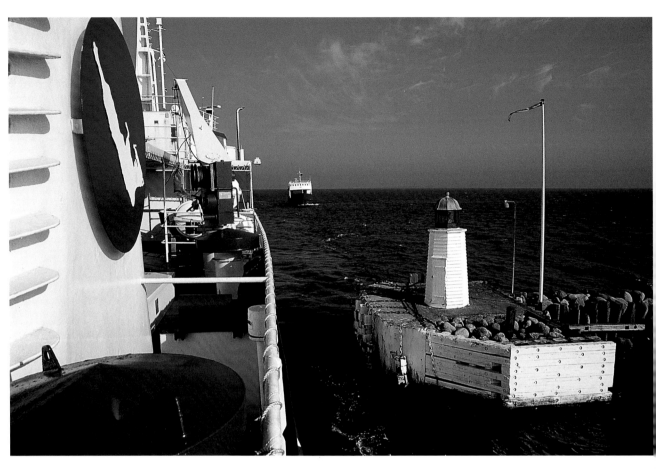

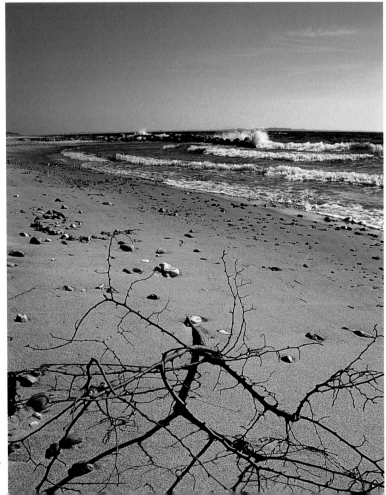

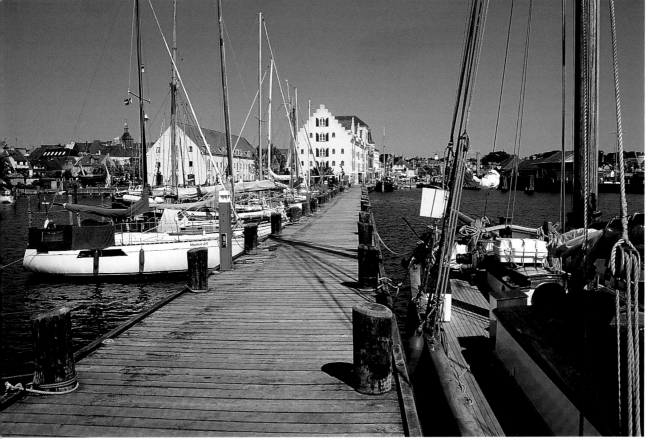

Above:
One next to the other, the sailing boats crowd in the harbour of Lohals, the most northerly small town on Langeland. During the summer months the sounds of many tongues show that not only native skippers, but many sailors from Germany, Sweden and Norway drop anchor here.

Left:
In the harbour of Svendborg, Funen's second-largest city. One of the most famous citizens of Svendborg, Arnold Peter Møller, founded the Mærsk shipping firm, today the world's largest private shipping firm. The motor ship MS Helge from the year 1924, which shuttles during the summer months to Thurø and Tåsinge, is the harbour's main attraction.

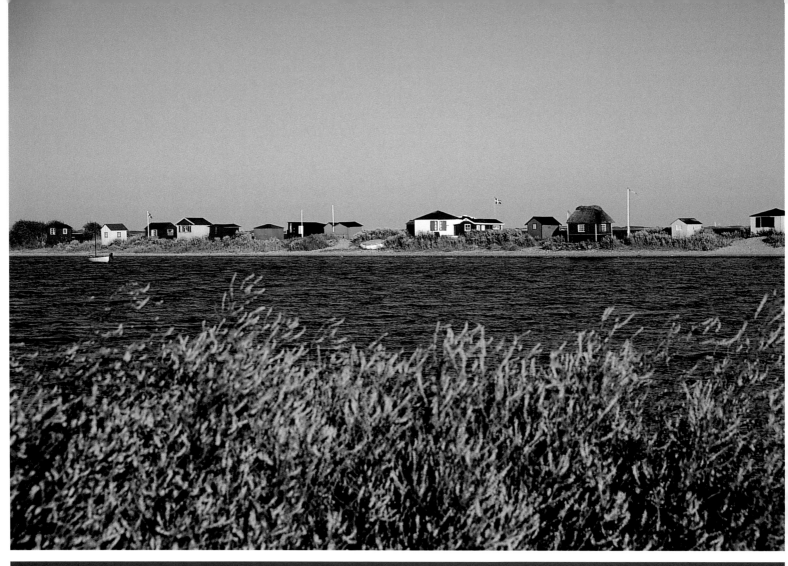

Left:
The bathing cottages stand all in a row on the beach of Marstall on Ærø. They are all privately owned and have been handed down within families over generations. In the summertime this is a busy place.

Small photos:
Symbols of Denmark's culture of leisure: the bright bathing cottages, many of them built without permits and once threatened with demolition. Today they are fixed elements of island life on Ærø. Even the windows are lovingly decorated. The beach surrounding the elongated island so gently slopes into the waves of the Baltic that it is a bathing paradise, particularly for families with children.

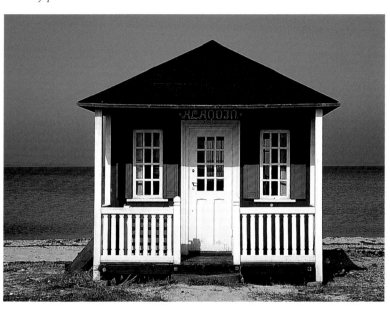

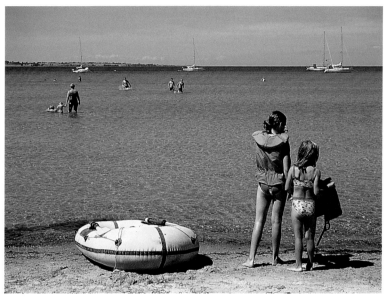

Left:
An idyllic Danish summer: small, cosy and colourful. Most of these bathing cottages on Ærø can be found on the Urehoved peninsula, close to Ærøskøbing.

79

The slant of the trees clearly shows which way the wind blows in Jutland – from the »Vesterhav«, or the West Sea, as the Danes call the North Sea. Wind, waves and the play of the tides give the Danish North Sea coast its unmistakable character: mile-wide beaches on the islands of Rømø, Mandø and Fanø in the tidal shallows, broad dune landscapes along the entire west coast and wide bays from Hanstholm to Grenen, where the North and Baltic Seas quite visibly collide.

Until the mid-19th century the western part of Jutland was hardly developed; the living conditions in the hinterland of the North Sea were too rough. But in the age of the Internet and mobile phones, the Danish North Sea coast with its countless holiday cottages is a synonym to European vacationers for peace and relaxation close to nature's wonders.

Contrasted with the wind-tossed beauty of the west coast is the hilly moraine landscape of eastern Jutland. The most visible expressions of prosperity and culture are the country estates and the many trade towns: Aabenraa, Haderslev, Kolding, Vejle, Horsens, Århus and Randers are arranged in rows at short distances from one another in the fjords named after them.

In Denmark everything is relative as shown by Yding Skovhøj and Ejer Bavnehøj: at 173 (568 feet) and 171 metres (561 feet) above sea level they rise as the highest »summits« of the country above the deep forests and waters of the Nordic lakeland surrounding Silkeborg. But the »top of Denmark« is the gently curving landscape of Vendsyssel, which is separated from the mainland by the broadly branching, quiet Limfjord. At its narrowest point Aalborg, the fourth-largest city, forms the busy bridge between the two parts of the country.

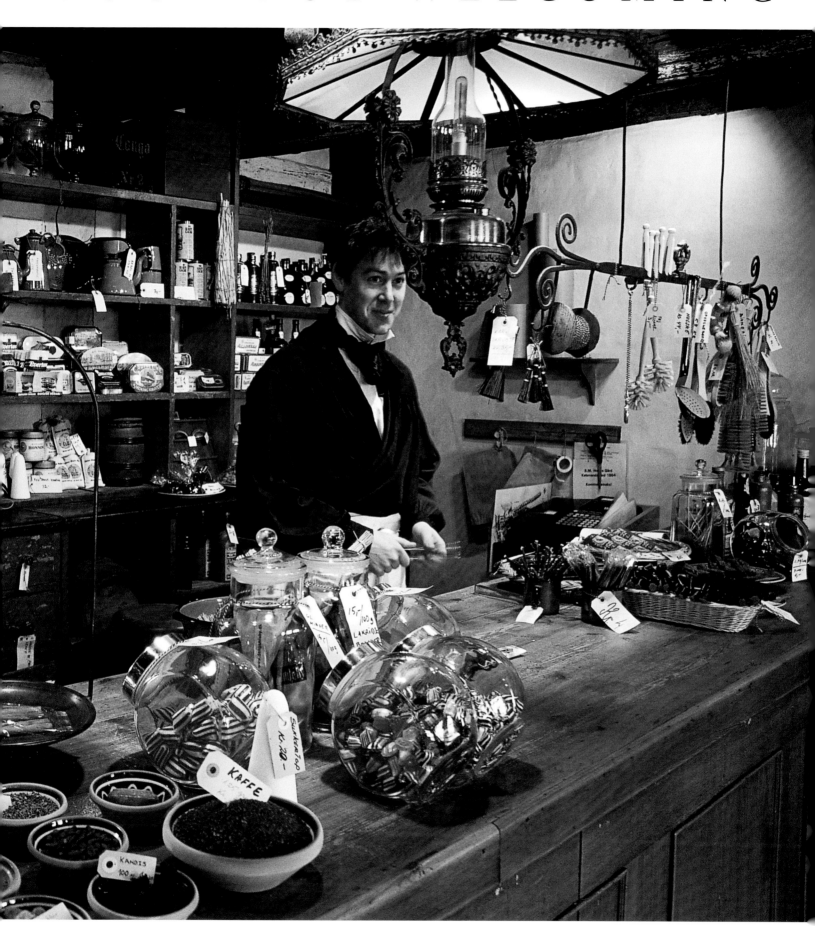

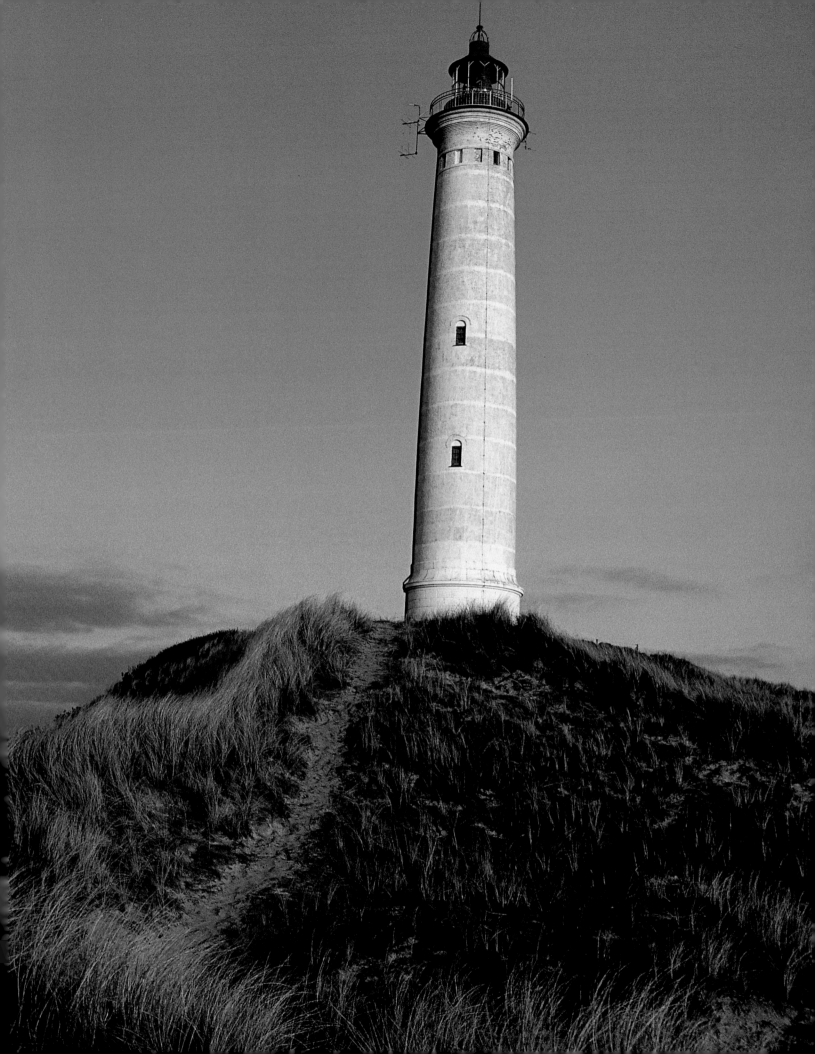

Left page:

Nørre Lyngvig Fyr lighthouse stands as a lonely admonisher in the dunes of Holmsland Klit on the west coast of Jutland. Fifty metres (164 feet) above sea level its beacon points far out into the often rough North Sea. The ships lost over the centuries on the west coast cannot be counted.

After stormy days the North Sea beaches are often littered with algae that the wind whips over the sand. Like here by Hirtshals the northwester winds then press the open sea against the land. Those who love the raw freshness of the North Sea find a retrieve here even in autumn and winter.

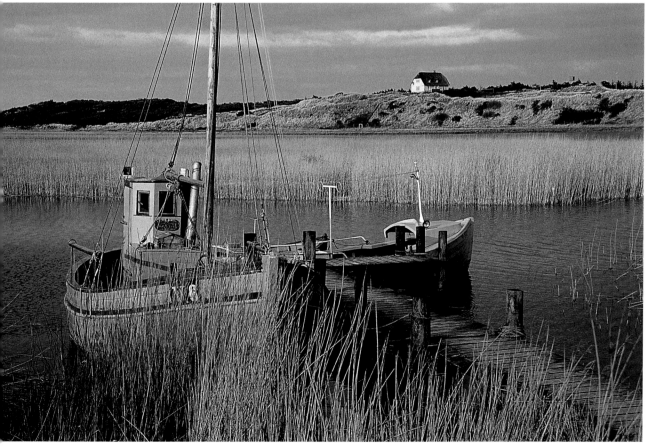

The southern end of Ringkøbing Fjord is silting up increasingly, yet the largest lagoon of West Jutland is still fished successfully. At one time here by Nymindegab there was a land connection between the fjord and the North Sea. Today a lock near Hvide Sande regulates the water depth.

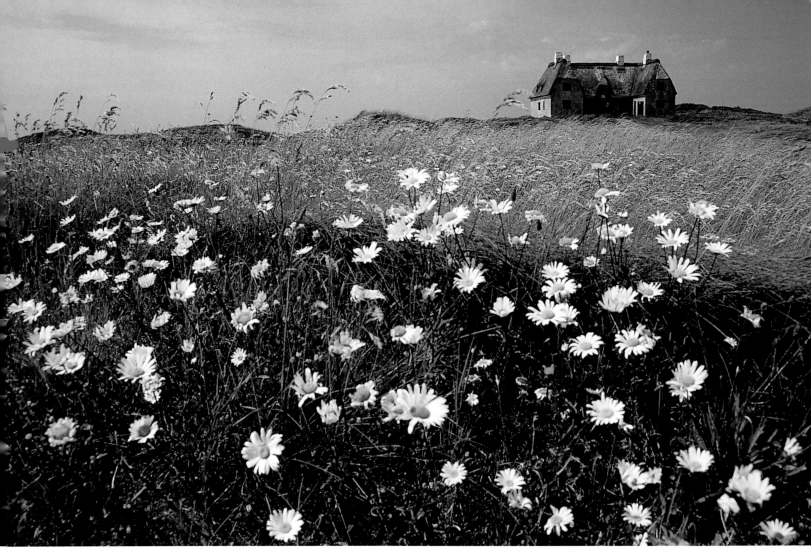

Above:

Blossoming dune land-scape near Hanstholm. The power of the North Sea is so great that even the dismal bunkers left behind by the German occupiers from the Second World War disappear in the sand. Only the up to 30 metre (98 feet) high dunes can successfully bring the play of the winds and tides to a halt.

Right:

Roughly 680 gravesites from the Iron Age to the Viking Age have been found in the northern district of Aalborg, north of the Limfjord in Lind-holm Høje. The most impressive are the stones positioned in the shape of ships about 1000 years ago.

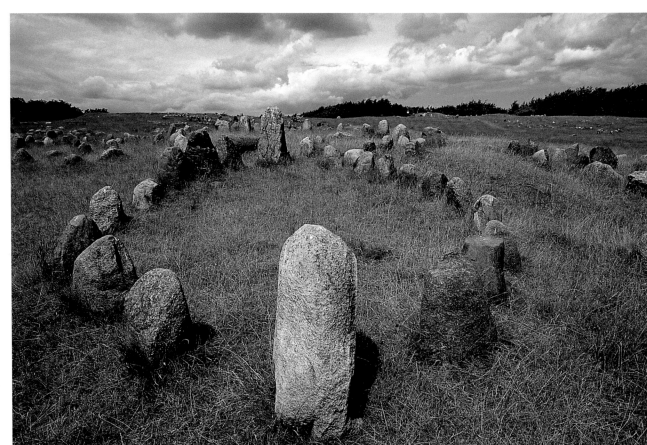

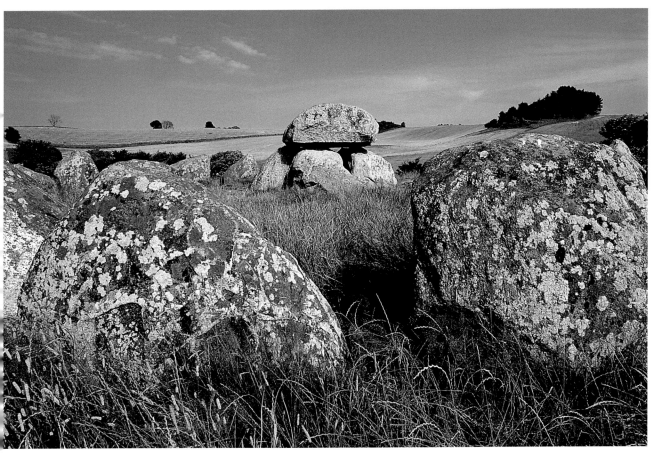

Left:
The up to 137 metre (450 feet) high Mols Bjerge to the northeast of Århus are among Jutland's most unusual natural monuments. The dolmen grave called Poskær Stenhus near the little village of Knebel is an historic testament of the Stone Age.

Below left and right:
The rune stones of Jelling are the »birth certificate« of the Danish kingdom. Harald Blåtand (Bluetooth) (c. 945–985) successfully united the small kingdoms of the country to one sphere of power. The portrayal of Christ (left) reveals that Harald Bluetooth Christianized the Danes.

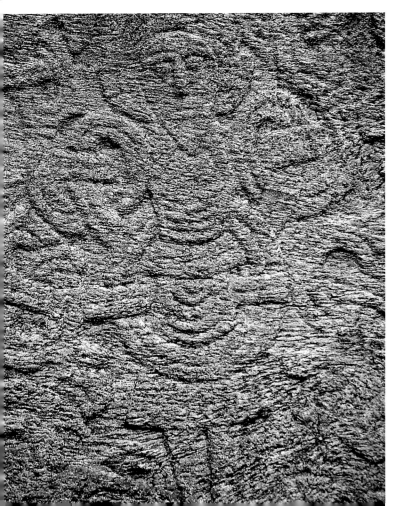

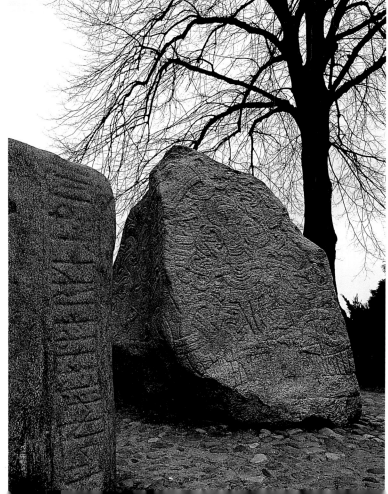

Right:

Today Schackenborg Slot, originally a bishopric castle, is the home of Prince Joachim and his wife Alexandra. The Danish royal family owes the splendour of the non-public castle complex to a public collection.

Below:

The Slotsgade, the castle lane in Møgeltønder, is one of the loveliest village streets in Denmark. Most of the Frisian-style, reed thatched and bay-windowed houses originate, like the cobblestone lime-tree-lined avenue, from the mid-18th century. The little town's prosperity is owed to Schackenborg Slot, near the German border, in early days one of Denmark's largest estates with roughly 1000 hectares of land.

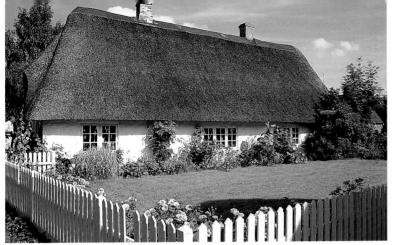

Left:
The reed-thatched
Frisian houses, typical of
the marsh landscapes on
both sides of the Danish-
German border, are not
all as well-preserved as
this one in Møgeltønder.

Below:
Tønder is the welcoming
hub of the southern Jut-
land marsh landscapes.
The well-preserved centre
of the old trading city
invites us to take a stroll

through its lively history,
marked by lace pro-
duction in the 17th and
18th centuries. Tønder's
former wealth is still
visible in many details.

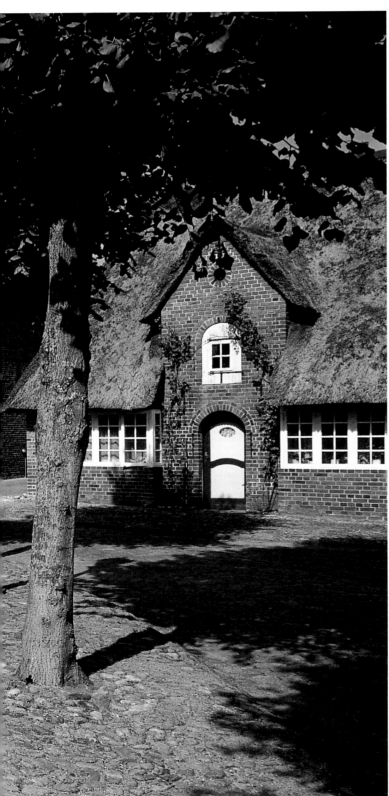

Above:
Royal tourism in
Møgeltønder has made
the prosperity of the
town clearly visible:

affluent clientele with
a love for the world of
beautiful things are very
welcome here.

DAINTY AND HEARTY PLEASURES

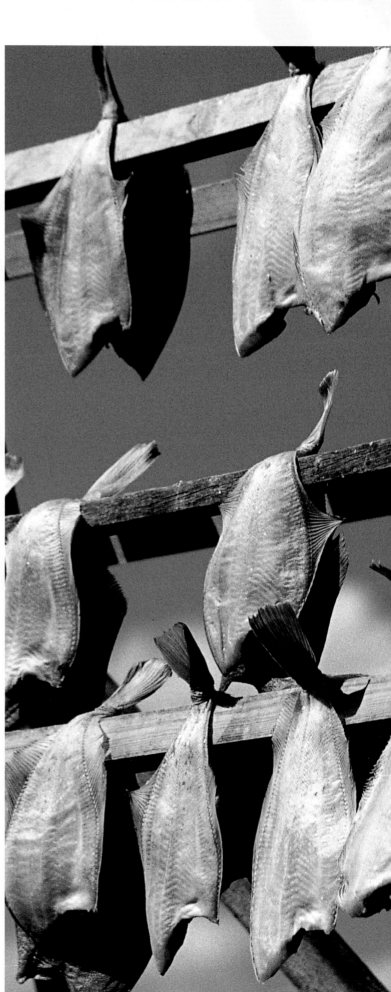

Calorie-counters and »haute cuisine« devotees might find it hard to get used to the country's culinary peculiarities, but those who enjoy solid, authentic meals that take full advantage of native raw materials will certainly feel at home in Denmark and forget about burgers and fries. There are exceptions to every rule though and the »risted hot dog«, Denmark's version of the frank and bun, finds friends even among the most outspoken opponents of fast food.

The table is laden with whatever intensive farming and the sea provide: beef, pork and lamb, sausages and cheeses of all imaginable kinds, potatoes, vegetables and, of course, no end of fish – fresh, dried, smoked, breaded and pickled. »Smørrebrød«, probably the world's most artistic version of an open sandwich, is a delight to all of the senses: a small slice of bread is lovingly adorned with the most diverse ingredients and garnishes making it a feast for the eyes as well as the palate. In spite of the growing influence of international gastronomic competitors, small businesses dedicated exclusively to the production and sale of works of art in bread can still hold their own, particularly in Copenhagen. Yearnings for finer cuisine are directed, in spite of all things native, towards France: Danish-French cuisine has become a fixed gastronomic constellation.

Left:
Denmark's pigeons and sparrows love the »pølser-vogn«, the city sausage carts. Order a »risted hot dog« with a bun, sausage, mustard, remoulade, sweet pickles, roasted and fresh onions, and just try to eat it without making a mess!

Right:
Fresh from the sea to the fresh air. Not only air-dried cod is a delicacy, plaice is also a speciality.

Page 89 centre:
Who wouldn't want to stop here? The friendly waiter inviting us into the »kro« of Dunkær, is an example of the cordial hospitality of the often centuries-old taverns. The spectrum of quality ranges from simple pubs to two-star gourmet temples.

Page 89 bottom:
In Skagen harbour everything revolves around fish. The freshness of the wares that come to shore here is unmatched, and whatever is not sold at the auction is deliciously served right next door.

Left:
Smørrebrød – the literal translation, »bread and butter,« for this skilfully arranged culinary work of art does not do it justice. Smørrebrøds have always been a fixed part of mealtimes, especially at midday, in Denmark.

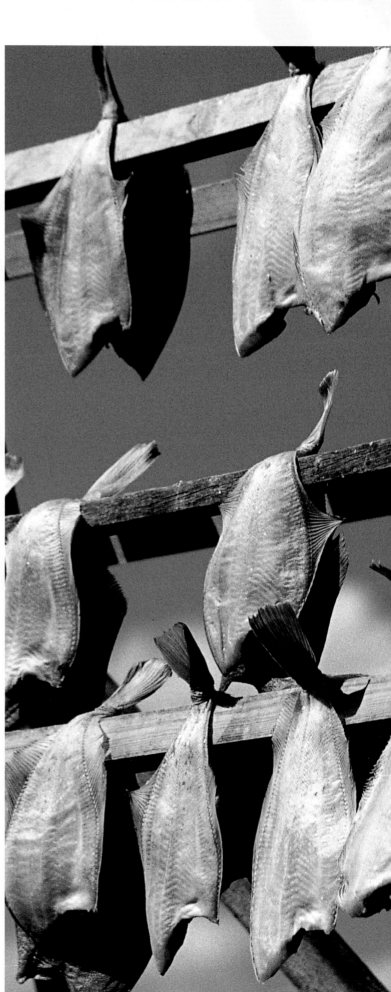

– DENMARK'S COOKERY IS SINFULLY GOOD

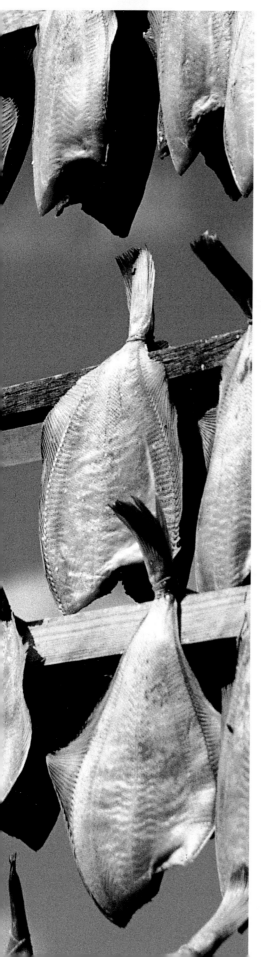

KOLDTBORD AND
GAMMEL DANSK

The best way to get a first impression of rustic Danish cooking is traditionally »det store koldtbord«, a rather inexpensive cold buffet – only one of the many confusing mealtime terms, as the guest also has a choice of many warm dishes. Starters consist of shellfish and different types of pickled herrings. Salmon and smoked fish, as well as plenty of sausages, hams and poultry, form the bridge to warm fish and meat dishes, usually freshly apportioned by a skilled hand. The many puddings, creams, cakes and ices are often a climax leaving hardly any room for the fruit and cheese. The liquid supplement to this not-very-low-calorie journey

through Denmark's kitchen are »øl« and »snaps«, beer and schnapps. Not necessarily Tuborg or Carlsberg – many small local breweries can quench thirst just as well with their good-tasting beers. The question of »snaps« is clear though: the most popular spirits are the caraway schnapps »Rød Aalborg« and »Aalborg Jubilæum«. Only »Gammel Dansk,« an herbal bitter that requires some getting used to, is equally appreciated.

For in-between snacks it's a good idea to stop at the local bakery: fresh bread and »rundstykker« (rolls) are delivered fresh to the counter many times daily. In Denmark Danish pastries are called »Wienerbrød« and »kransekage«, puff pastries and cakes with all kinds of fillings.

Before you go out to eat in Denmark it's wise to first take a look at the prices – not every restaurant that looks pricey is; by contrast even modest looking restaurants, particularly in the cities, can burn a hole in your pocket. The »kroer«, Denmark's typical country eateries found everywhere along main traffic routes in the country, usually offer a realistic price-performance ratio: many of them have served as taverns and inns for hundreds of years and their interiors are often accordingly cosy. A stop here for »frokost«, the midday meal, or »middag«, the evening meal is a guarantee of a good, solid Danish meal. The unusually large, high-quality offering of red wines, which compete successfully against the breweries, is always a surprise: French wines in particular can be found in the most remote taverns.

89

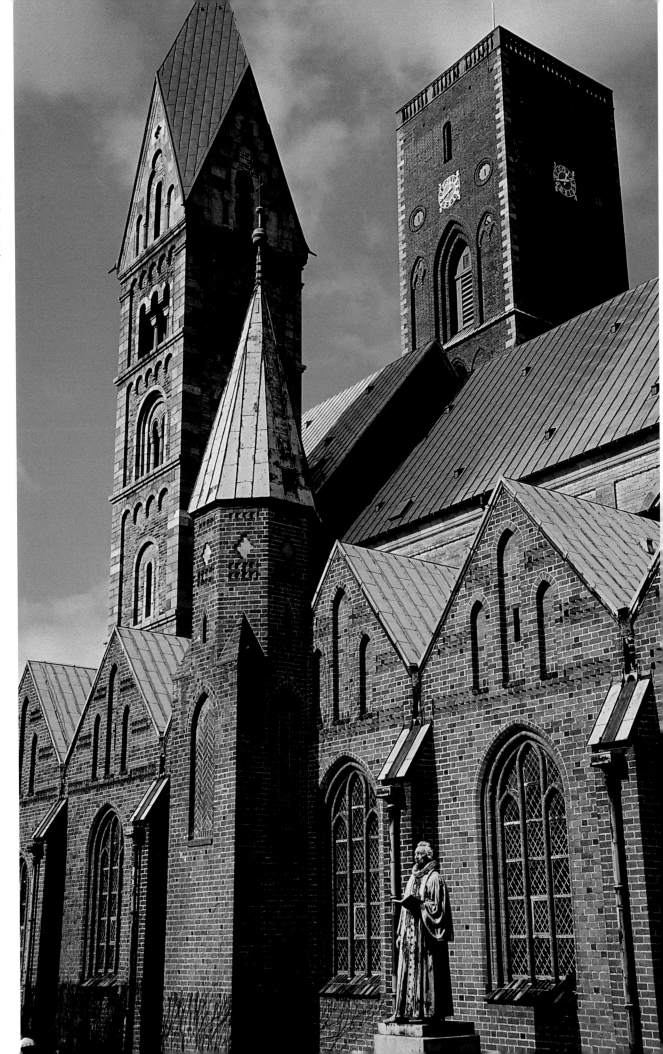

Ribe Cathedral is Jutland's most important sacred building. It was constructed between 1134 and 1225 as a triple-nave basilica and its Romanesque core is similar to the late-Romanesque churches of the Rhineland. The top of the massive-looking 14th century Borgertårn observation tower offers a fantastic panoramic view of the broad marshlands.

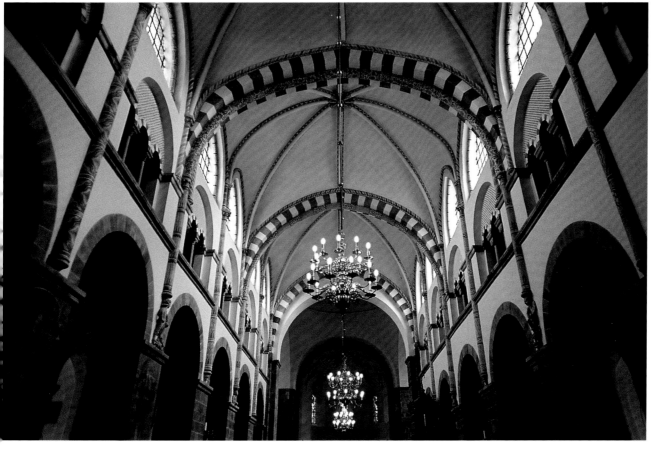

German tuff and sandstone and Jutlandic granite were used to construct the Romanesque interior of the cathedral church of Ribe. But changes and extensions gave the cathedral Gothic, Renaissance and Baroque elements.

Until 1970 Møgeltønder Kirke belonged to Schackenborg Slot, which explains its unusually ornate interior. Its tower, with a one-handed clock built in 1663, was a fixed landmark for seafarers for many years.

Below:
Right in the centre of Højer is northern Europe's largest wind-mill, built in the Dutch style. Today it houses the tourist office as well as the Mill and Marsh Museum.

Right:
The little town of Højer in the very southwest corner of Jutland is situated on a sandy plateau that lies like an island on the marsh-lands. Its earlier wealth can be seen in the well-preserved reed-thatched Frisian houses with ornate doors.

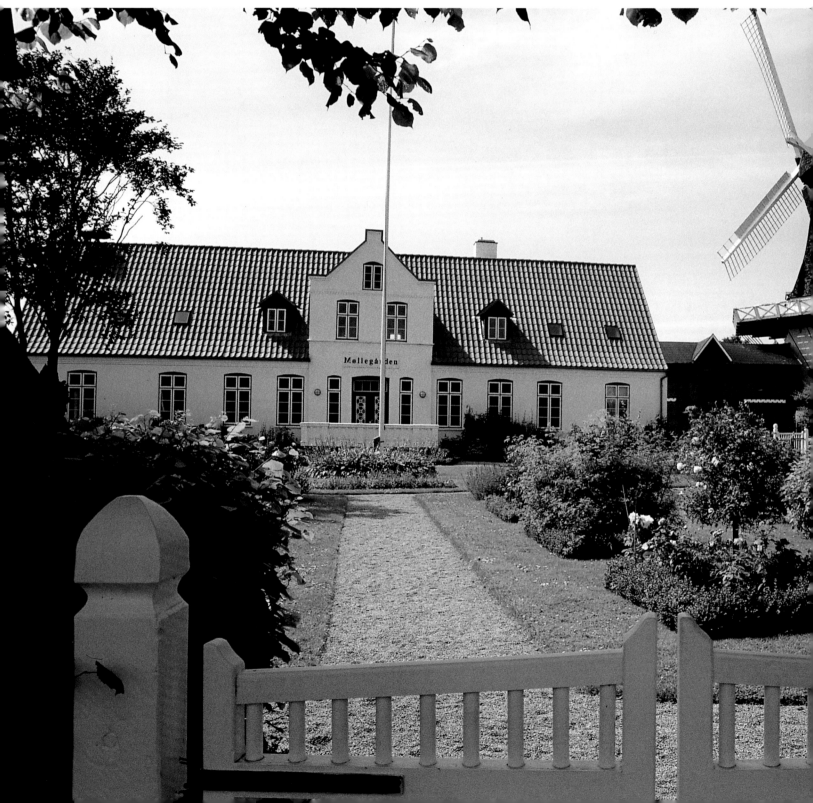

Left:
Ribe has been able to preserve its late medieval appearance like hardly any other town in Denmark. The city elders very skilfully integrated the architectural legacies of the past in a vital community.

Below:
In the dark hours of the night, visitors to the western Jutland city of Ringkøbing can count on the protection of the night watchmen, who still make their rounds here as in days of yore.

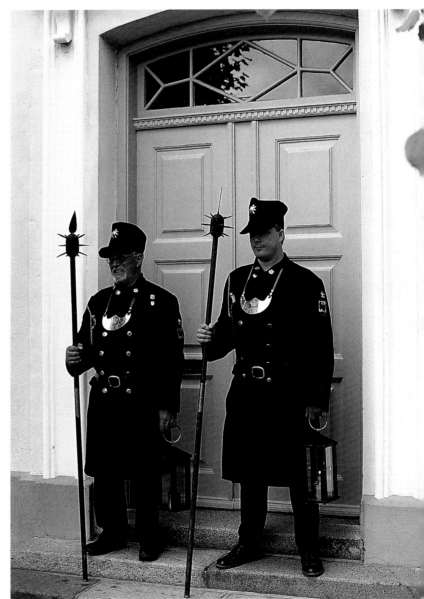

93

The traces of Denmark's largest open-air museum »Den Gamle By« in Århus go back to the 16th century. »The old town« consists of 75 buildings from all over Denmark, that were threatened with demolition and, since 1912, have regained their old brilliance in the country's second-largest city, Århus. Old toys, porcelain and historic clothing can be seen in numerous special collections.

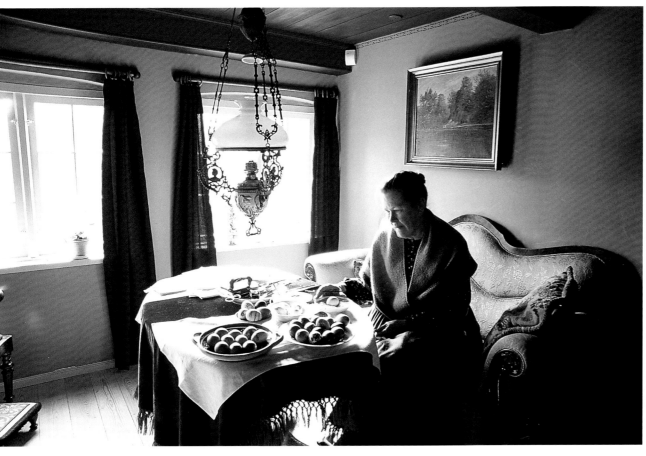

Life in olden days is demonstrated in the houses of Den Gamle By open-air museum. Operas and plays performed in the former municipal theatre of Helsingør are a very special experience. The complete structure from 1817 was transported piece by piece to Århus in the 1950s, where it has become a fixed element of cultural life. During warmer months, promenade concerts every Sunday produce a folklore atmosphere.

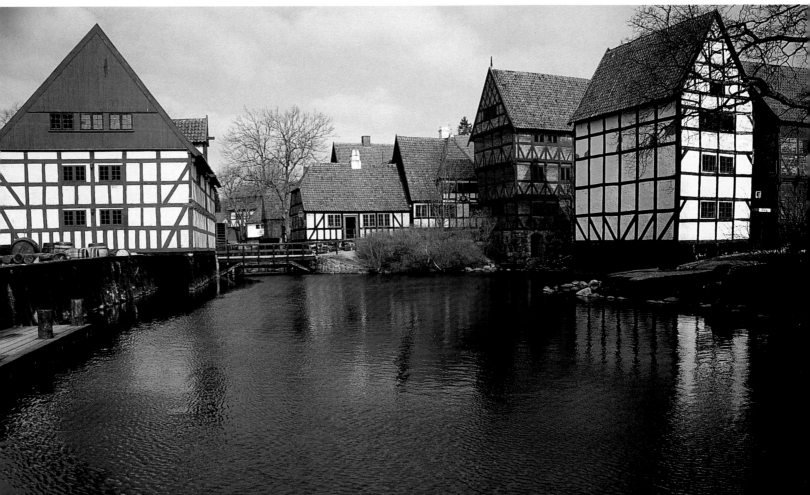

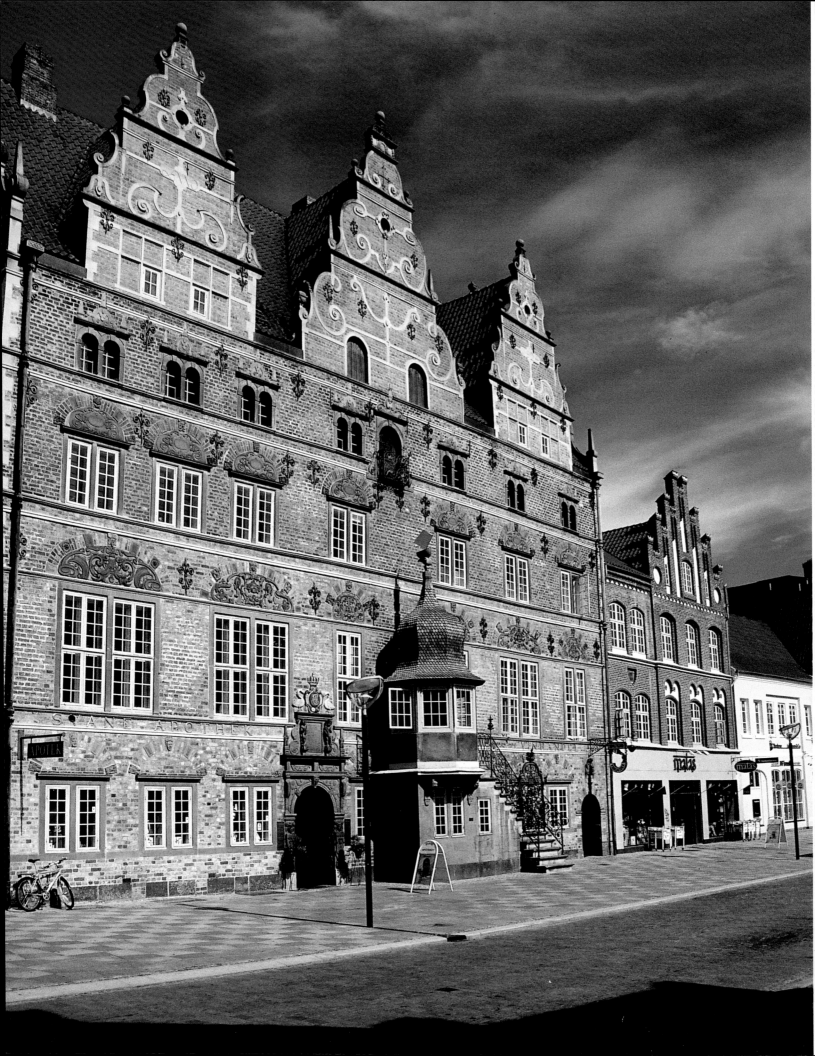

*It is considered northern
Europe's most beautiful
bourgeois house in
Dutch Renaissance style:
the Jens Bangs Stenhus
from 1624, named after
its builder, the ship-
owner and merchant
Jens Bang, is the jewel of
the city centre of Aalborg.
It clearly displays the
wealth and passion for
grandeur of the merchant
elitist class of those times.*

*Although its is North
Jutland's no. 1 industrial
site and service industry
centre, the greater mu-
nicipal area of Aalborg/
Nørresundby with a
population of 155,000
has preserved many
tranquil niches. Jomfrue
Ane Gade, Denmark's
most famous pub-lined
street, is legendary.*

*Aalborghus Slot was
erected by Christian III
between 1539 and 1555,
but only the eastern
wing has been preserved
in its original form.
Today it belongs to the
Danish state and is the
headquarters of the
regional government of
North Jutland.*

97

One of the most absurd and yet charming buildings in Denmark is the snail house, »Sneglehuset«, on Klitvej no. 9 of the West Jutland harbour town of Thyborøn. The fanciful palace is a declaration of love by the fisherman and Thyborøn eccentric Alfred Pedersen to his wife: the towers, niches and walls are decorated with seashells from all the seven seas. Inside the snail house visitors can admire a larger collection of ships in bottles.

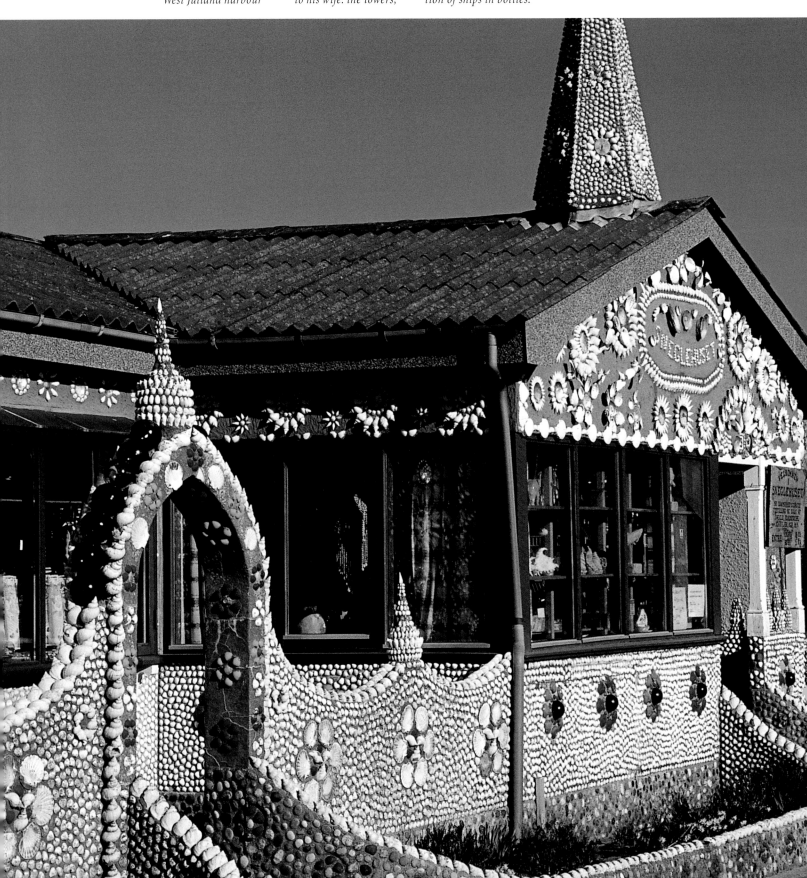

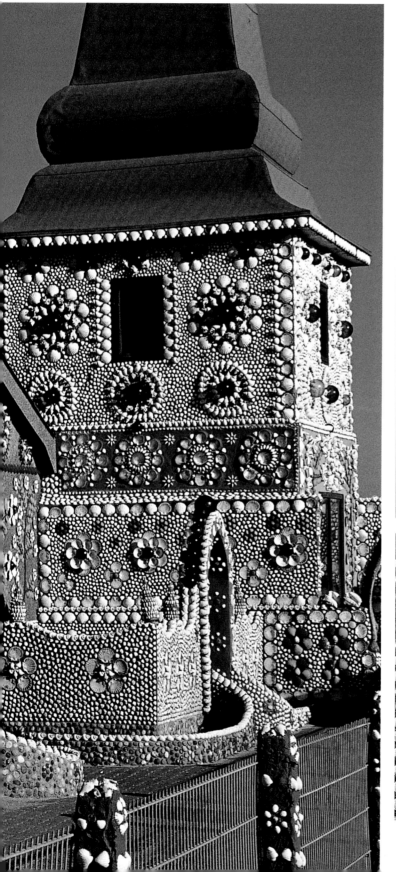

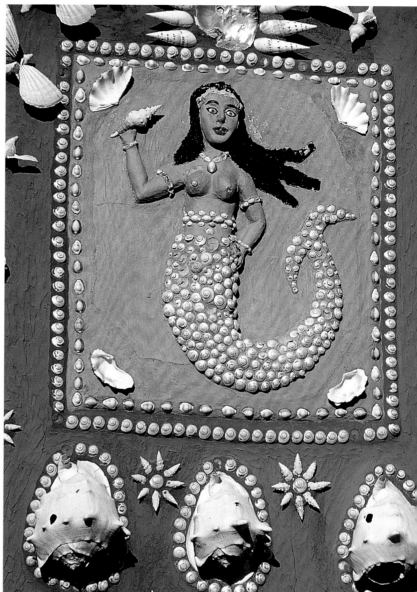

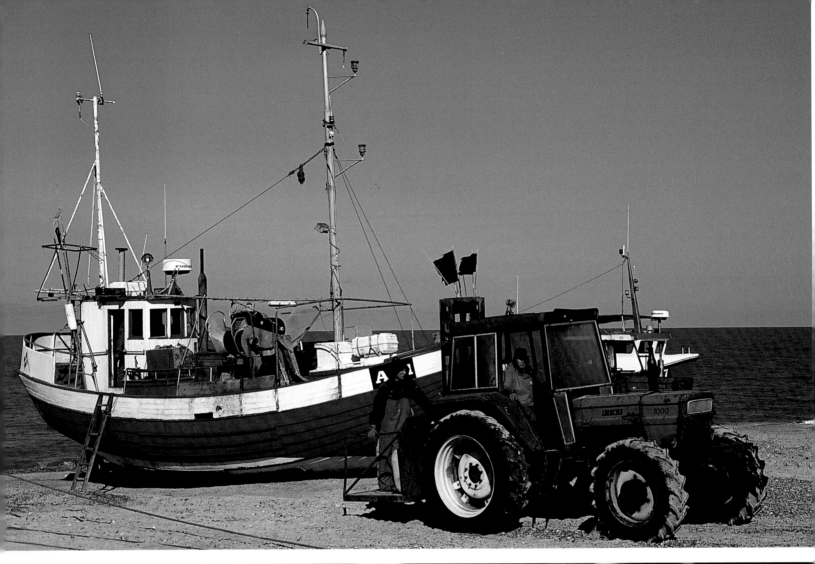

Above:
Because it lacks a proper
harbour, in Nørre Vorupør
west of Thy the fishing
trawlers are pulled ashore
and then pushed back
into the water before the
next tour. It may make a
tremendously picturesque
impression on tourists,
but for the town's fisher-
men it's a real grind.

Right:
Fresh from the sea and
into the smokehouse: the
fishing port of Hirtshals
is the sixth in line along
the entire western coast
of Jutland besides
Esbjerg, Hvide Sande,
Thorsminde, Thyborøn
and Hanstholm.

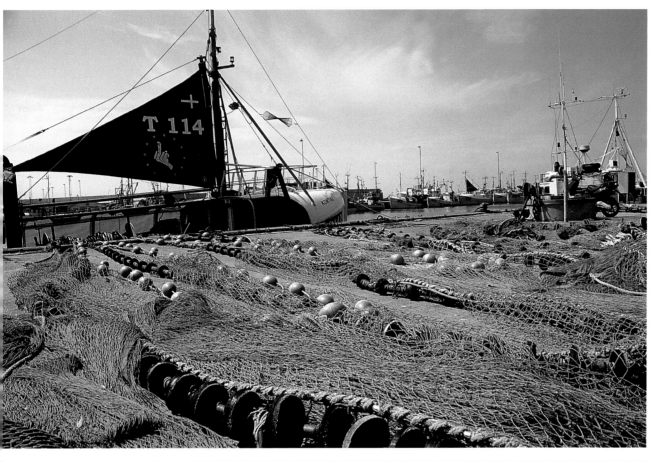

Left:
In spite of the most modern fishing methods, drying, mending and arranging the nets is still essential work. In the harbour of Hanstholm, also the ferry port to Norway, the Færø Islands and to Iceland, not only the Danish fleet lands its catches. Trawlers from other nations also sell their loads here.

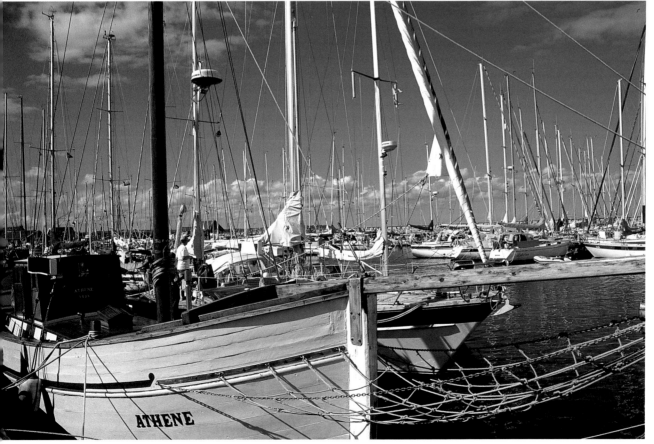

Left below:
The marina at Sæby, the old port and fishing town to the south of Frederikshavn, is a popular landing place for sailors from neighbouring Scandinavia. Even the Vikings took advantage of the natural shelter of the river mouth of the Sæby Å.

Pages 102/103:
On the tip of Jutland the free play of wind and waves creates unsurpassed natural spectacles. One of the most dramatic is a hike of the roughly 90 metre (295 feet) high dunes inland from Rubjerg Knude. They have long sealed the fate of the Rubjerg Fyr lighthouse: the beacon, which first showed the ships their way on the North Sea in 1900, has long gone out – because it is no longer visible from the sea.

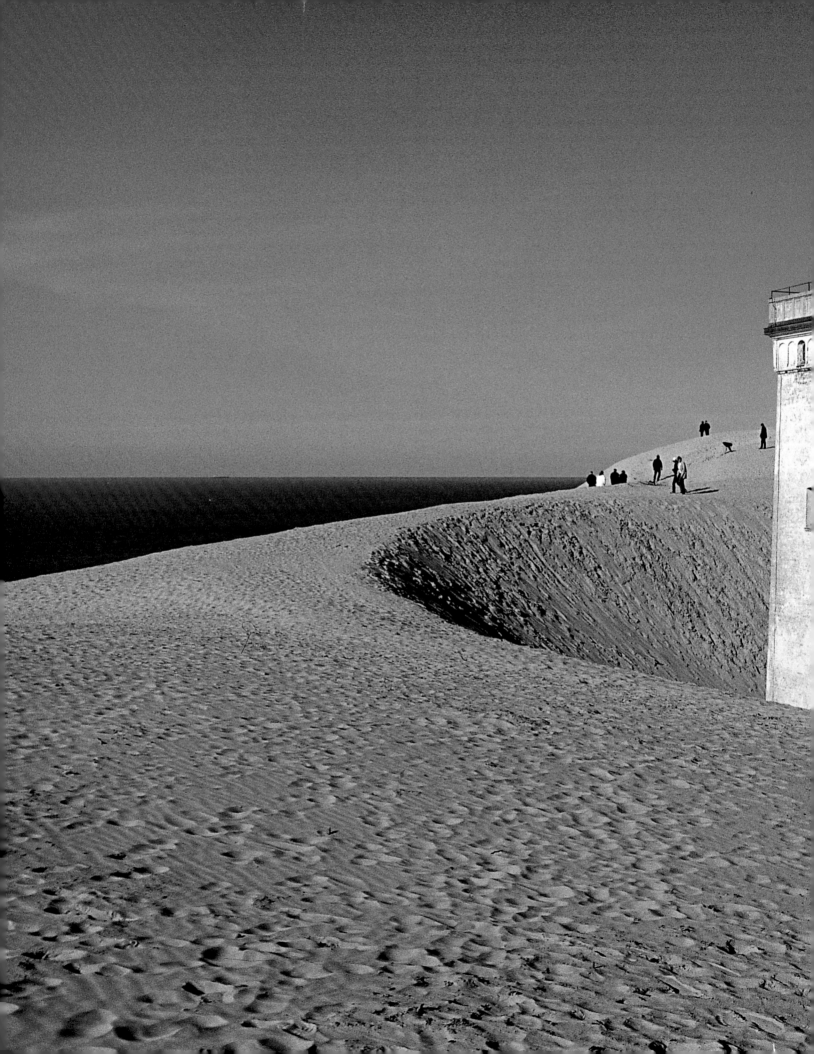

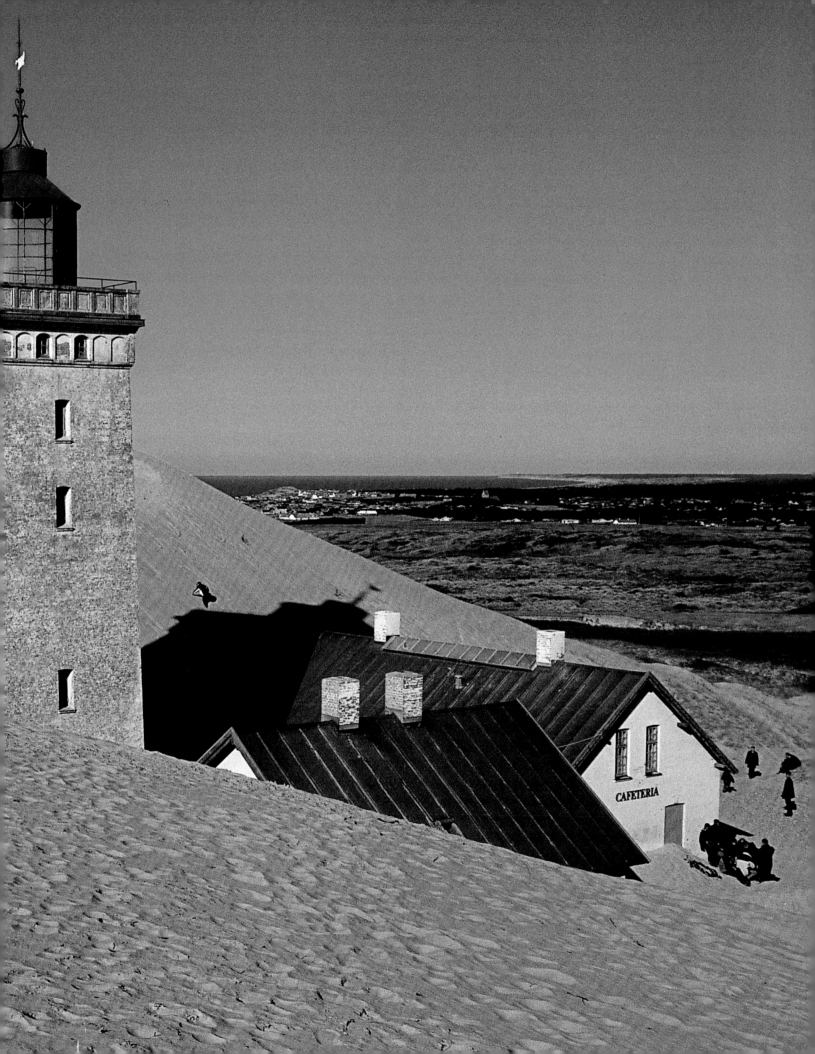

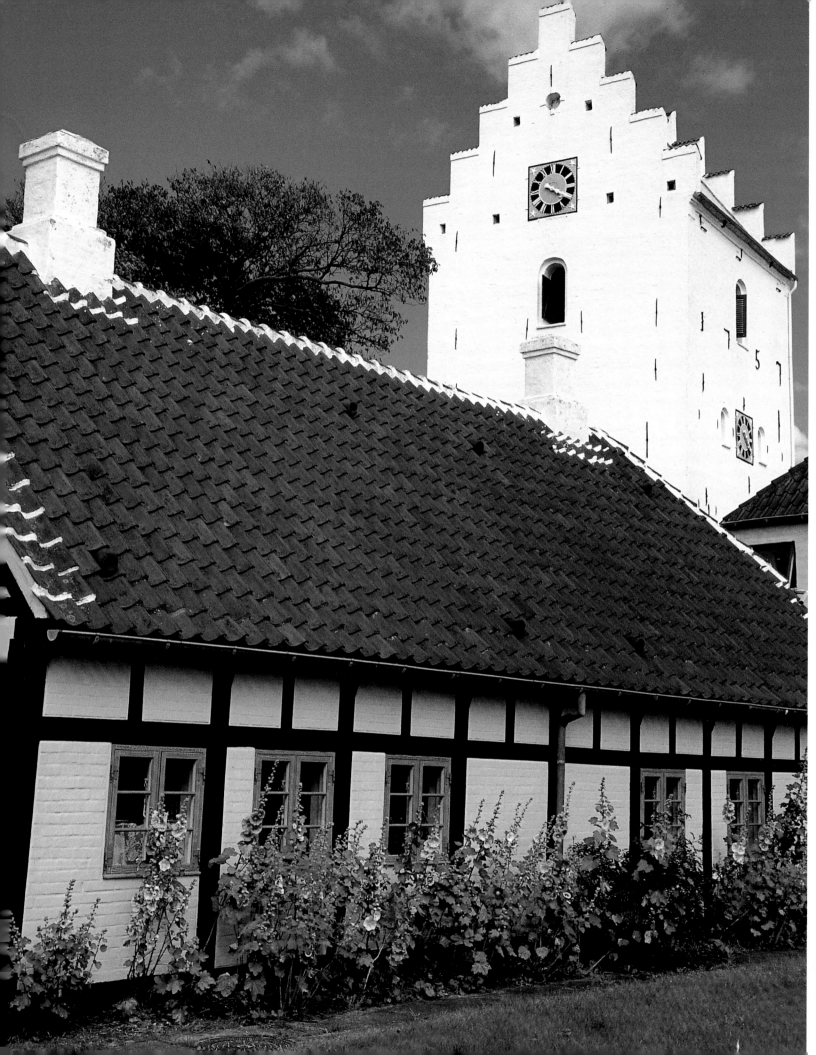

In brilliant white the stepped gable tower of St. Marie Kirke rises above the quaint old town of Sæby. Inside are Gothic limewash paintings and a Dutch altarpiece from the 16th century.

The Limfjord Museum in the little port town of Løgstør can only be reached over a foot-bridge above the Frederik VII Canal. The former canal attendant's hut, built in 1867 a bit later than the waterway, today houses a large exhibit on regional trade, fishing and shipping. In spite of being open to both the North and Baltic Seas the Limfjord is only rarely used as a through-waterway due to its many shallows.

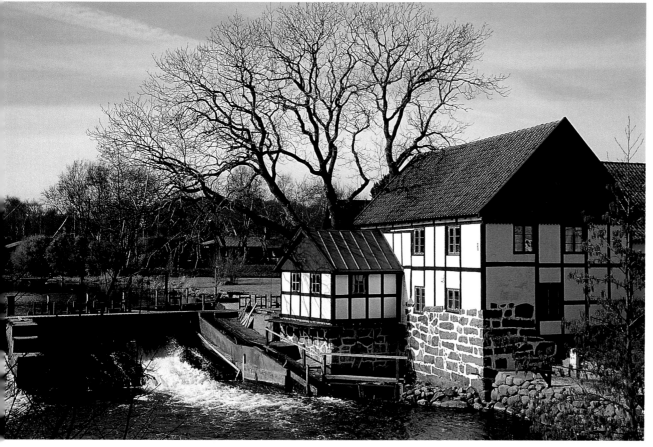

Sæby and its surroundings are still a quiet idyllic holiday destination. The reputation of this harbour town of 8,000 inhabitants in the shadow of the busy Frederikshavn was underscored by writers such as Henrik Ibsen and Herman Bang (1857–1912), whose Impressionist novel »Summer Pleasures« is one of the classics of Danish literature.

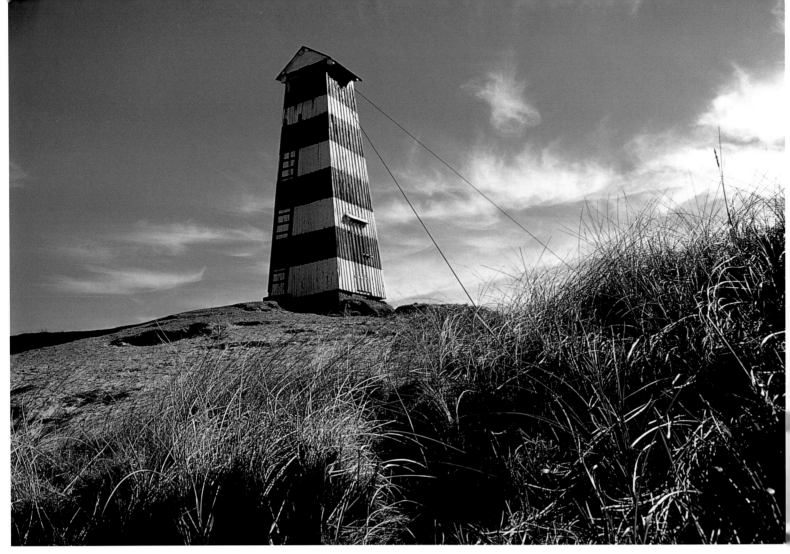

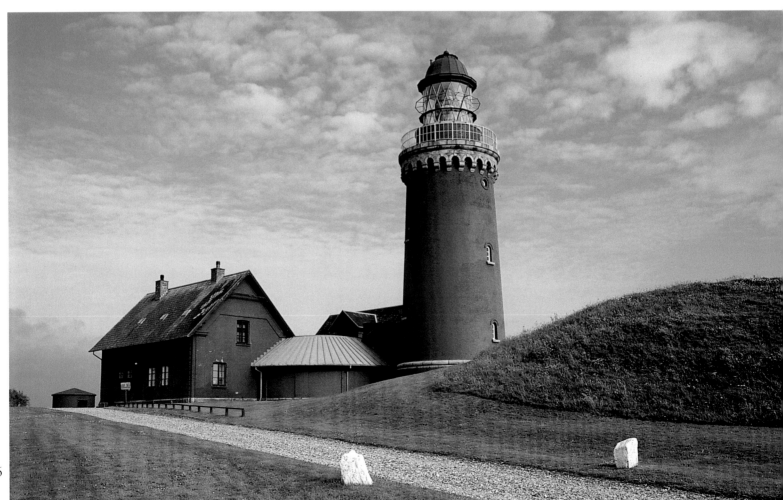

Left:
Red-and-white striped, but squarish and not very high, the lighthouse of Nørre Vorupør sits enthroned over the fishing village where the trawlers are pulled ashore with tractors and winches due to the lack of a harbour.

Below:
The reconstruction of the first beacon on the Danish coast – by Grenen at the tip of Jutland – looks more like an ancient well. The principle was quite simple: a basket with glowing coals hanging on a lever arm bobbed up and down.

Below:
The lighthouse of Hirtshals looks down over a busy port town and its main attraction, the North Sea Museum. Here everything revolves around life under the water's surface. Hirtshals is the ferry port to Norway with ships directly serving Kristiansand, Larvik and Oslo.

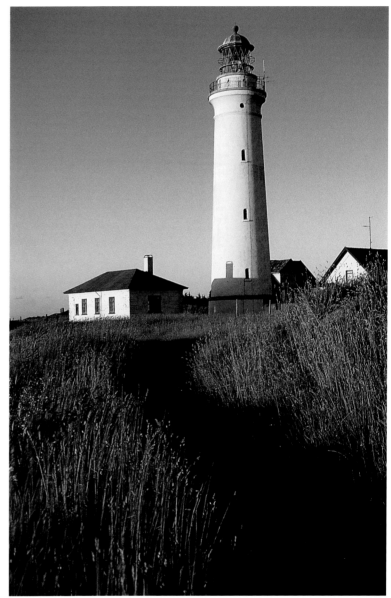

Left:
The 26 metre (85 feet) high tower of Bovbjerg Fyr offers a magnificent view of the sea and the rather hilly local country that came to an abrupt halt here as the end moraine of the last Ice Age. Only a few hundred metres away lies the little village of Ferring, made famous mainly by the painter Jens Søndergård (1895–1957).

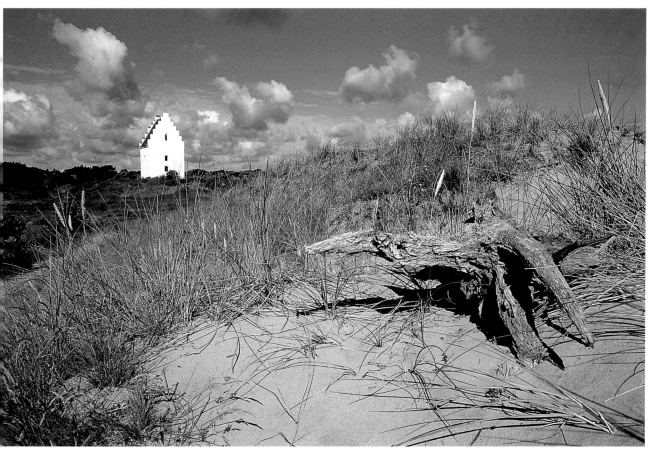

Left page:
At Grenen we reach the
very tip of continental
Europe: here the waters
of the North and Baltic
Seas collide so distinctly
that it's possible to stand
with one foot in each sea
at the same time. Every
ship entering or leaving
the Baltic Sea can be
seen passing by here.

The tower of the sand-
covered St. Laurence's
Church, half of which
still peeks out of the
earth, is Skagen's land-
mark. Built about 1350,
the then largest church
in the Vendsyssel region
could only be reached
with great efforts when
the sands began to move
– they had to dig to make
it to Sunday services.

The 800 metre (2626 feet)
wide and two kilometre
(1.2 mile) long wander-
ing dune Råbjerg Mile
»travels« up to 20 metres
(66 feet) per year from
west to east. It's already
made it to the halfway
point between the two
coasts of Skagen.

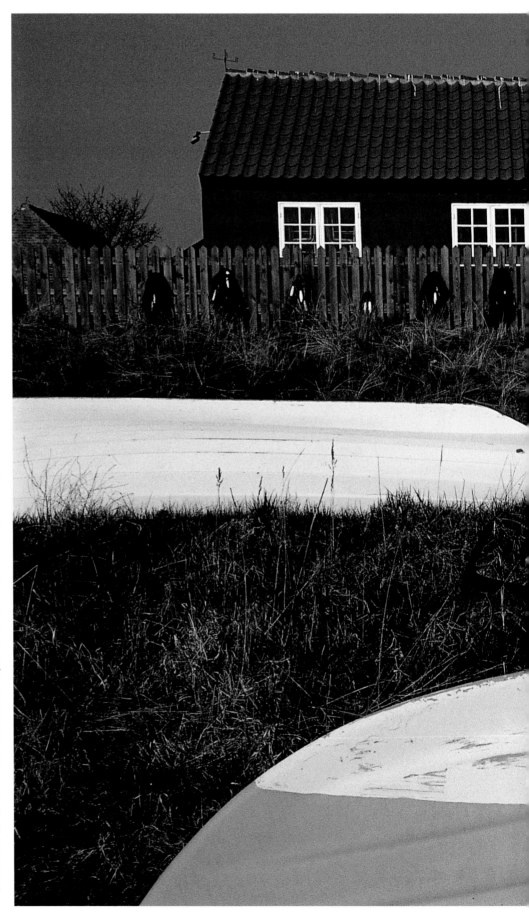

The harbour of Snogebæk on the east coast of Bornholm. The characteristic rows of chimneys are evidence of the smokehouses here. Herring, shrimp, salmon, cod and plaice fresh from the smokehouse are delicacies that can be enjoyed in nearly all of the island's small harbour towns.

If its inhabitants had not defended themselves successfully against the new Swedish lords in 1658, the blue and yellow flag would fly over Bornholm today. The permanent guarantee of protection awarded by the Danish king for their rebellious heroic deeds has often proved to be a difficult obligation since the Bornholmers still sometimes feel like a neglected appendix of the mother country. The chalk cliffs of Møn – Denmark's next closest landmark – are 135 kilometres (84 miles) away, the German island Rügen only 90 kilometres (56 miles) and Sweden's southern coast a mere 40 kilometres (25 miles). But the most easterly outpost of Denmark is unbelievably popular: like none other of the nation's roughly 500 islands, Bornholm enjoys a reputation as a refuge and idyllic holiday destination. Positioned in the middle of the Baltic Sea, Bornholm is the only part of Denmark that is part of the Fenno-Scandinavian mountain shield. The magnificent testimony to the geographical curiosity is the mighty rock coast in the north of Bornholm which is more reminiscent of the north of Norway than of the country where milk and honey flow. But if you look into the gardens and courtyards of Gudhjem, Svaneke and the other little towns you will see nothing of Norwegian chill: sheltered by the cosy half-timbered houses, grapevines, mulberry and fig trees confirm the meteorological fact that Bornholm is Denmark's most sun-blessed region. This explains the unbelievably rich, deep colours of nature here: the deep green of the enchanted Almindingen, the third-largest joined forest area of Denmark, invites the visitor to take long hikes and bike tours through the middle of the island. The blazing white of the beaches surrounding Dueodde in the south with sand so fine it is even used for hourglasses. Again and again we get a glimpse of the blue Baltic Sea, whose moods determine the rhythms of island life.

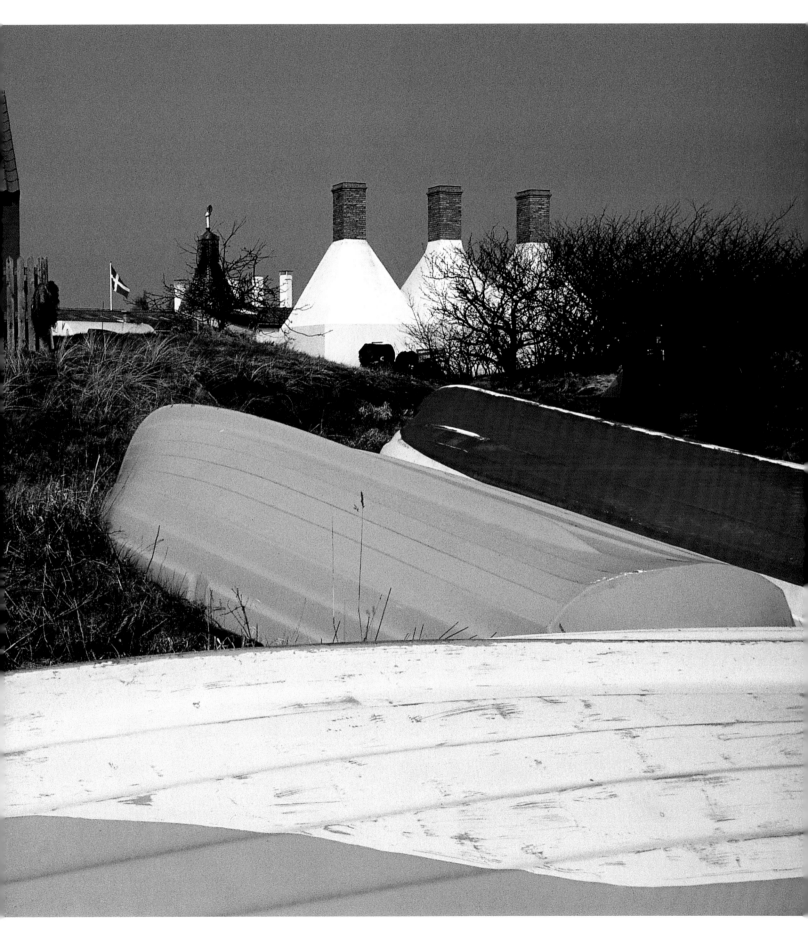

Pages 112/113:
The houses of Gudhjem snuggle close together on the steep rocky coast in the northeast of Bornholm. Their bright yellows and reds are a wonderful contrast to the blue and grey of the Baltic Sea. The plays of colour are impressively documented in the works of the painter Oluf Høst, whose legacy can be viewed in the museum named after him in Gudhjem.

The round church of Østerlars is the most beautiful of its kind. The island possesses four of these unusual sacred buildings, with the oldest sections from the 12th century. The vault of the nave is supported by a central pillar.

The Bornholm round churches were all built of granite from the island. Their side buildings, here the free-standing bell tower of the round church of Nylars, were built later and most of them of simple masonry.

Right page:
The somewhat onion-shaped spire is the most noticeable characteristic of the church of Nexø, built in the mid-15th century and dedicated to Nicolas, the patron saint of seafarers. The church structure was damaged in early May 1945 during the town's bombardment by Soviet planes.

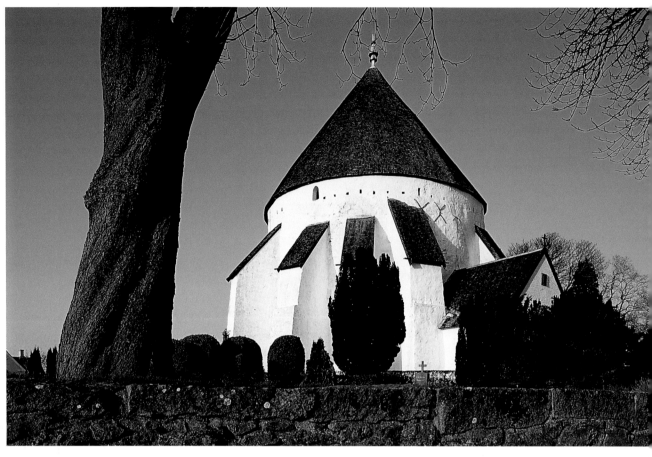

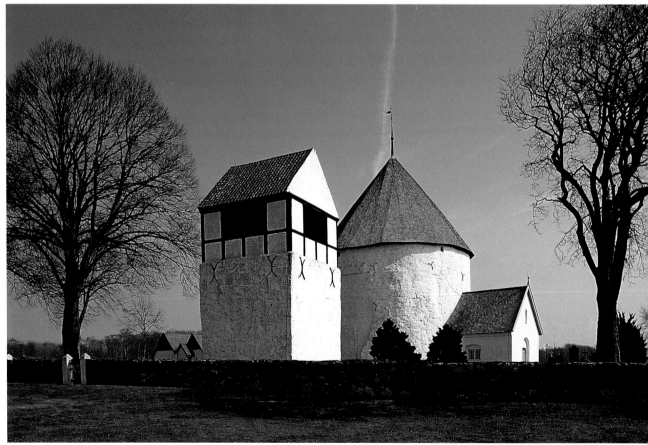

114

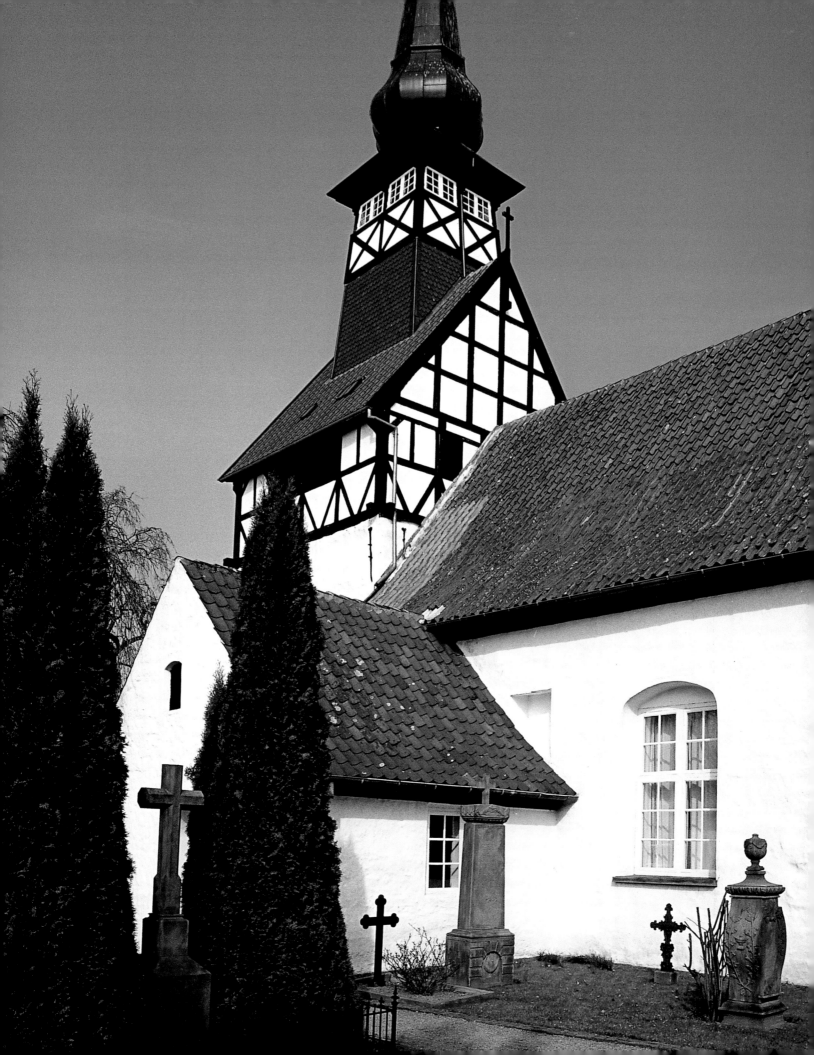

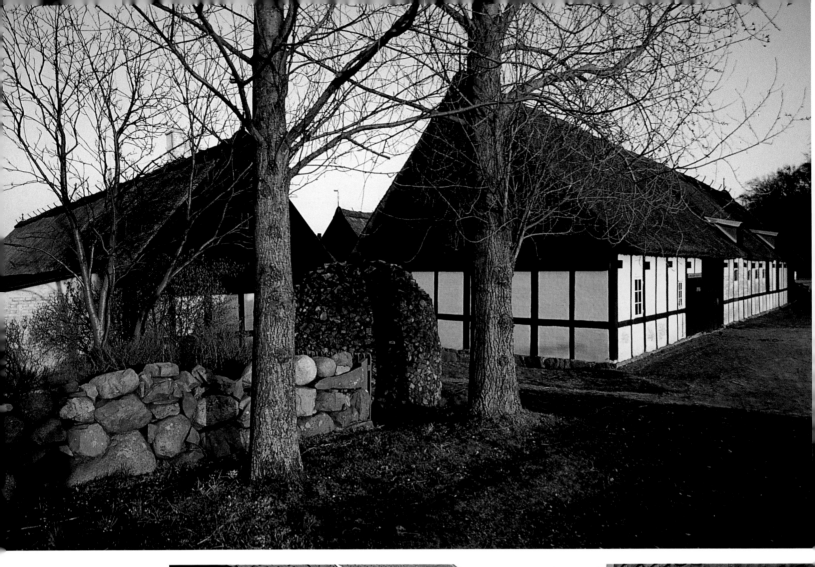

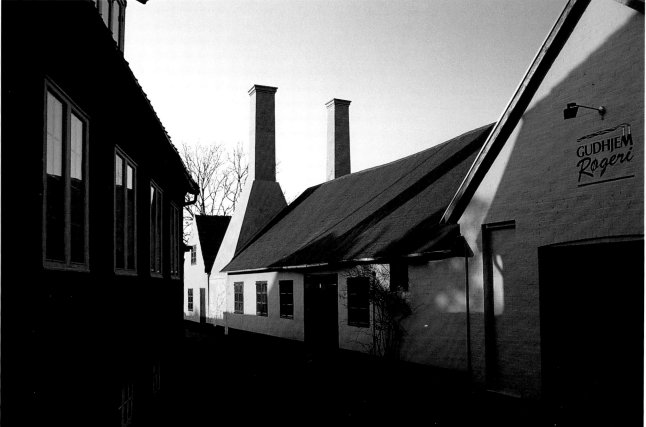

Above:
The harbour town of
Rønne counts roughly
14,500 inhabitants.
Ferry lines leave here
for Copenhagen, Ystad,
Sassnitz and Swinouyscie.
In spite of a bombard-
ment by Russian planes
in May 1945 large parts
of the old town have
been preserved like a
living open-air museum.

Left:
The smokehouse of
Gudhjem traditionally
offers »all the fish you can
eat«: for a reasonable
fixed price guests can
eat as much smoked and
marinated seafood as
they can handle.

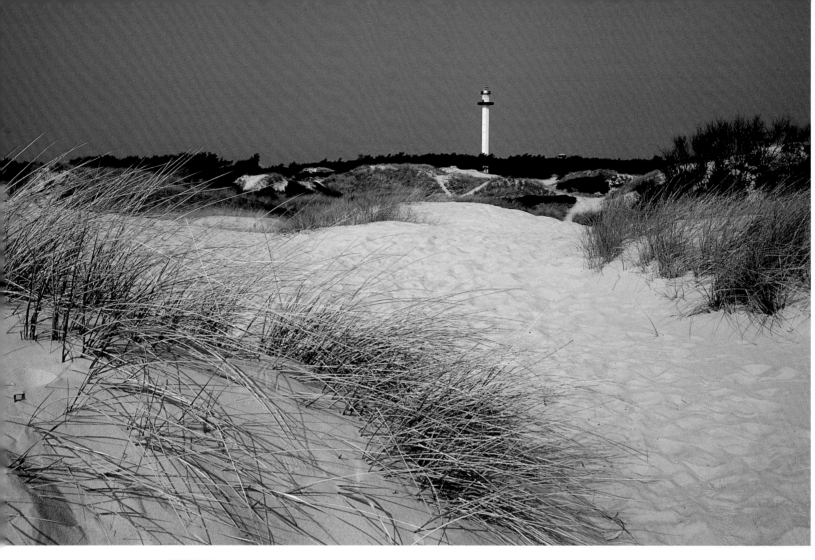

Above:
The sand on the beach of Dueodde is so fine that it is used around the world in hourglasses. The broad dune landscapes of the south-eastern corner of Bornholm is a stark contrast to the rocky northern coast.

Right:
The small but sufficient beach of Sandvig-Allinge is highly populated in the summer months, since nearly half of the island's hotel rooms are located here in the north. Still the town has lost nothing of its charm, as it remains a tranquil place. Huge hotel complexes and noisy entertainment centres are sought in vain on Bornholm.

Left:
The Helligdomsklippen is named after a spring attributed with healing waters. The sheer, deeply indented rock coast stretches between Tejn and Gudhjem and can be hiked via an interesting trail.

Below:
Visible from afar the ruin of the Hammershus fortress testifies to the strategic importance of Bornholm and the island's momentous history. Built around 1250 on the order of the archbishop of Lund, the castle repeatedly was the centre of numerous sieges. But its present appearance is not the result of warring conflicts – after it was given up Hammershus served for nearly eighty years as a quarry for the inhabitants of the surrounding towns.

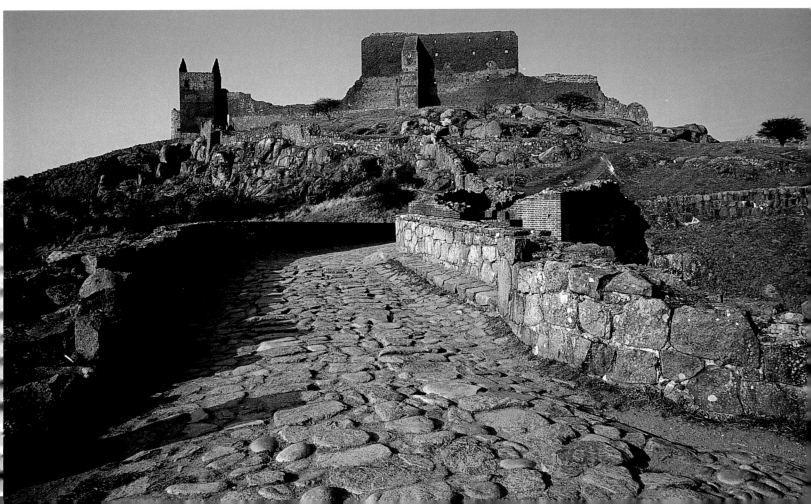

Right page:
Overfishing of the Baltic Sea also left clear traces on Bornholm: only 170 of the former 280 trawlers remain, many bigger ships were taken out of service. The seafood processing industry is doing far better since mainly fishers from the Baltic and Eastern European countries land their catches in Nexø.

Only a tiny emergency harbour protects the small fishing boats in Helligpeder. The little fishing settlement consists of only a few houses and reminds one of a village of dollhouses.

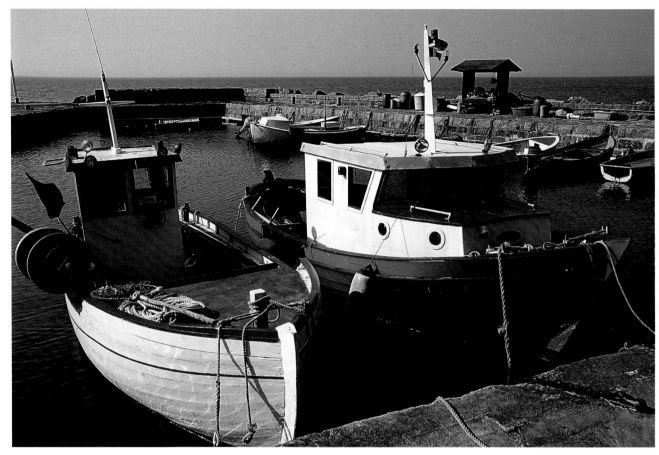

The two big hotels on the harbour, former estates of wealthy merchants, are misleading: the friendly harbour town of Svaneke has only 1200 inhabitants and is thus Denmark's smallest city. Long spared industrialization and fires, the up to 300 year old quaint buildings of Svaneke make a lasting impression on the visitor.

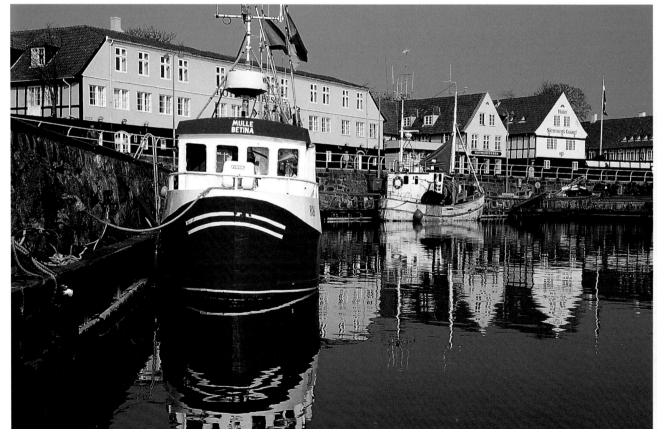

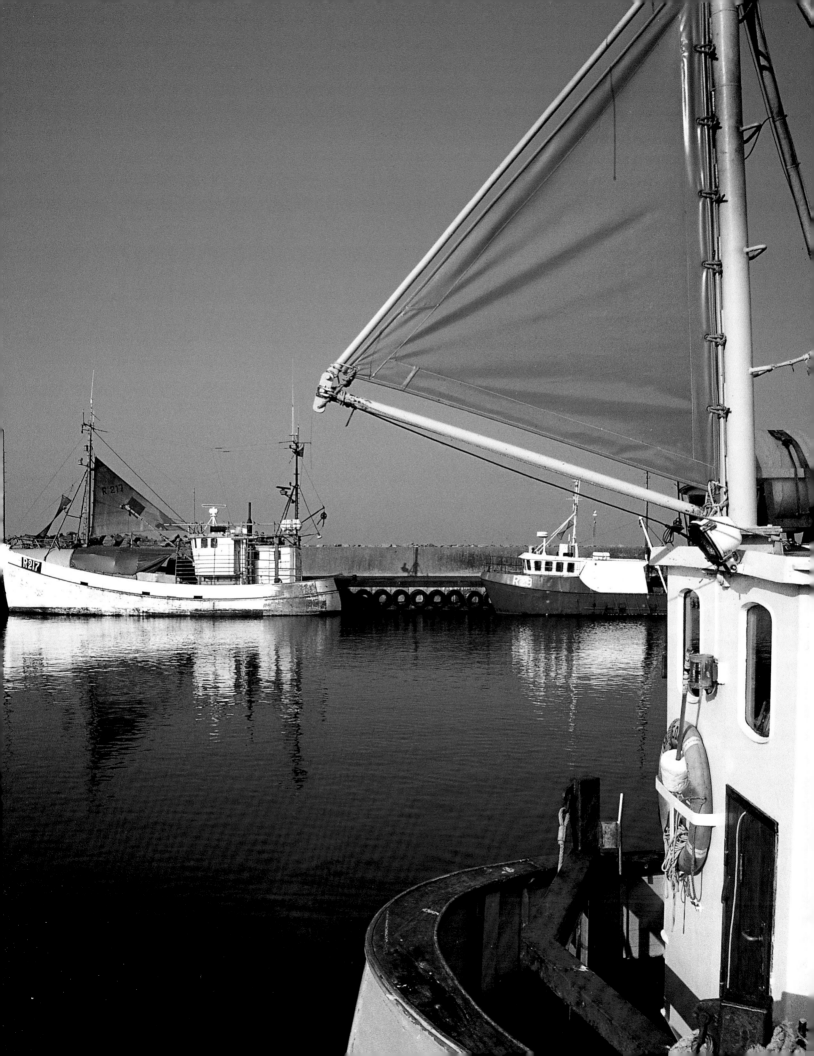

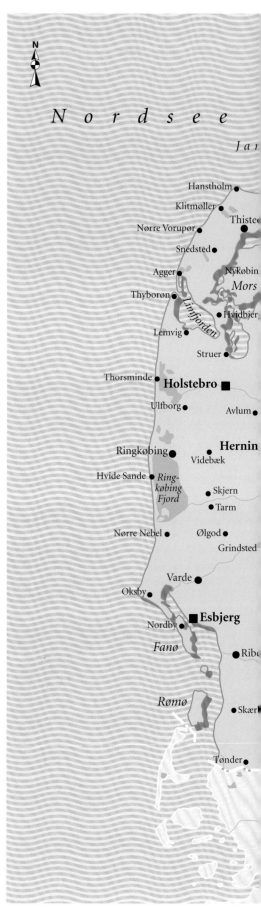

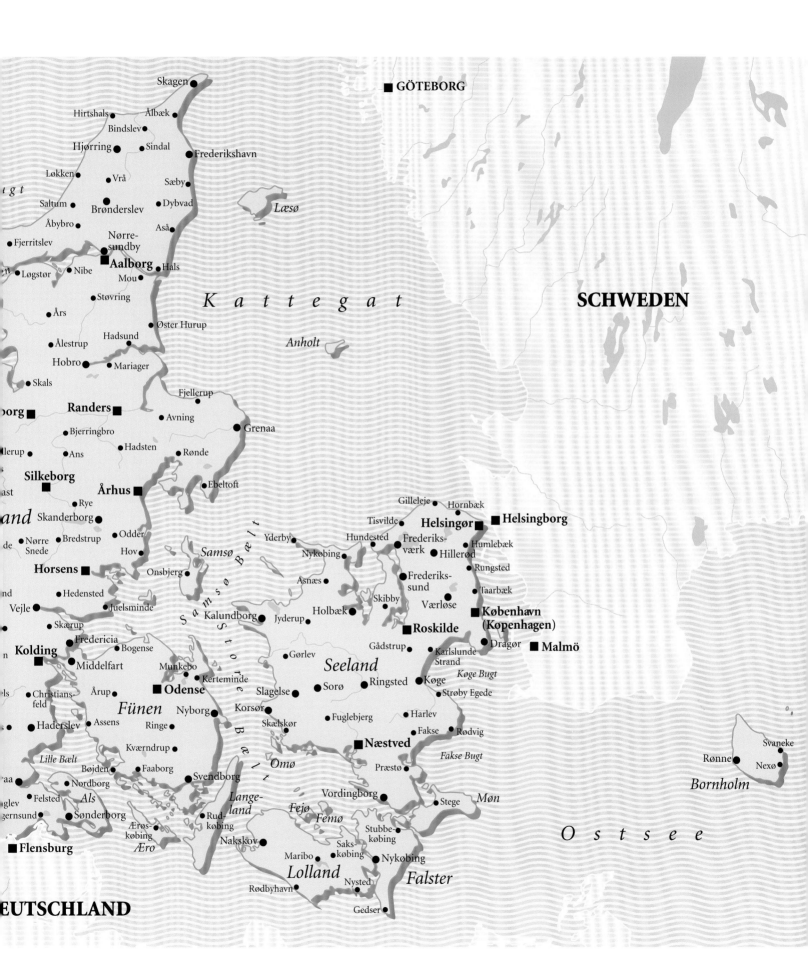

Skagen

GÖTEBORG

Hirtshals · Ålbæk
Bindslev
Hjørring · Sindal
· Frederikshavn
Løkken · Vrå · Sæby
Saltum · Dybvad
Brønderslev
Åbybro · Aså
Fjerritslev · Nørre-
sundby

SCHWEDEN

Kattegat

Løgstør · Nibe · Aalborg · Hals
Mou
· Støvring
Års
· Øster Hurup
· Ålestrup · Hadsund
Hobro · Mariager
· Skals

Anholt

Læsø

Fjellerup
borg · **Randers** · Avning
· Bjerringbro · Grenaa
lerup · Ans · Hadsten · Rønde
Silkeborg · Rye
Århus · Ebeltoft
and · Skanderborg
de · Nørre Bredstrup · Odder
Snede · Hov
Horsens · Onsbjerg
· Hedensted · Juelsminde
Vejle
· Skærup
· Fredericia
Kolding · Bogense
· Middelfart · Munkebo
Christians- · Årup · Kerteminde
feld · **Odense**
Fünen · Nyborg
Haderslev · Assens · Ringe
· Kværndrup
Lille Bælt · Bøjden · Faaborg
aa · Nordborg · Svendborg
glev · Felsted · *Als* · Rud-
gernsund · **Sønderborg** · købing
· Ærøs-
· **Flensburg** · købing
Ærø

Samsø Bælt

Yderby
Nykøbing
Asnæs

Gilleleje · Hornbæk
Tisvilde · **Helsingør** · **Helsingborg**
Hundested · Frederiks- · Humlebæk
værk · Hillerød
· Frederiks- · Rungsted
· Frederiks- · Taarbæk
sund
· Skibby · Værløse
· Holbæk · **København**
Kalundborg · Jyderup · **Roskilde** · (Kopenhagen)
· Dr
agør
Gørlev · Gådstrup · Karlslunde · **Malmö**
· *Seeland* · Strand
Slagelse · Sorø · Ringsted · Køge · *Køge Bugt*
Korsør · Strøby Egede
Skælskør
· Fuglebjerg · Harlev
· Fakse
· **Næstved** · Rødvig
· *Faxe Bugt*
Omø · Præstø
Lange- · Vordingborg · Stege · *Møn*
land · *Fejø* · *Femø*
· Stubbe-
Nakskov · Saks- · købing
· købing · Nykøbing
Maribo
Lolland · Nysted · *Falster*
Rødbyhavn
· Gedser

Store
Bælt

O s t s e e

Svaneke
Rønne · Nexø
Bornholm

The warms tones of the bricks and the reed-thatched roof of the Frisian cottage in Møgeltønder are reminiscent of the good old days.

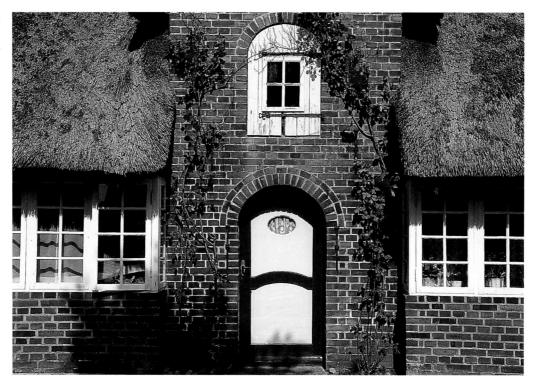

Credits

Design
hoyerdesign grafik gmbh, Freiburg

Map
Fischer Kartografie, Fürstenfeldbruck

Translation
Faith Gibson Tegethoff, Swisttal

Printed in Germany
Repro by Artilitho, Trento, Italien
Printed by Konkordia Druck GmbH, Bühl
Bound by Josef Spinner Großbuchbinderei GmbH, Ottersweier
© 2002 Verlagshaus Würzburg GmbH & Co. KG
© Photos: Tina and Horst Herzig

ISBN 3-8003-1600-5

Stürtz